IMAGES
of America
LOMBARD'S
LILAC TIME

March 29, 2010

ON THE COVER: The Lilac Queen and her court of Lilac Princesses are shown riding on their float in the 1936 Lilac Parade. Sadly, due to the Great Depression and World War II, this was the last year that the pageant and parade were celebrated until the Lilac Festival was reinstituted in 1947 after a 10-year lapse. (Courtesy of Lombard Historical Society.)

IMAGES
of America

LOMBARD'S
LILAC TIME

Lombard Historical Society

ARCADIA
PUBLISHING

Published by Arcadia Publishing
Charleston SC, Chicago IL, Portsmouth NH, San Francisco CA

Printed in the United States of America

Library of Congress Control Number: 2009938292

For all general information contact Arcadia Publishing at:
Telephone 843-853-2070
Fax 843-853-0044
E-mail sales@arcadiapublishing.com
For customer service and orders:
Toll-Free 1-888-313-2665

Visit us on the Internet at www.arcadiapublishing.com

*This book is dedicated to the many visitors that traveled
from near and far over the past 80 years to enjoy
the unique beauty and exotic scent of
the lilacs in Lombard's Lilacia Park.*

CONTENTS

ACKNOWLEDGMENTS

The idea of a book celebrating Lombard's Lilac Time, which occurs every year in the early spring, was a natural extension of the Lombard Historical Society's involvement with the event. Every year in the early spring, Lilacia Park comes alive with tulips and hundreds of lilac bushes in full bloom. Helping with the preparation of several events, as well as displaying a traveling exhibit at the coronation ceremony, the historical society has become an integral part of the three-week annual celebration.

A committee was formed to draw on the material in the archives of the Lombard Historical Society and write a story that would reveal the barely remembered early years of the original Lilac Pageants, the lost years during World War II, and the revitalization of the Lilac Time events after the war. The members of the committee were assigned chapters to tell the complete story of how Lilac Time began and developed.

Diane Zeigler pulled together a huge amount of material on the original pageants, as well as the names and participation of the Lilac Princesses from which one Lilac Queen was selected to rule over the Lilac Festival for one to three days. Diane's efforts in recording and organizing the information for the first 50 years did not take just a day, or a week, but went on for several months of evaluation of the numerous photographs stored away.

Pat Shaver worked on the thousands of slides and photographs from the 30 years of Lilac Parades that were available. I am sure that after looking at so many parade photographs, they all began to look alike, yet she managed to extract the most unusual floats or units during that time and still keep a sense of humor.

Jeanne Schultz Angel worked through the historical material to prepare the initial chapters: Colonel Plum, the man who had a curiosity and natural quest to collect hundreds of varieties of lilacs for his personal garden; Jens Jensen, a man who developed a role as a landscape and garden designer; and the information on Lilacia Park, designed by Jensen.

And we acknowledge the participation of Jennifer Amling Michaels, Katherine Cortesi, and Margot Fruehe, who prepared some of the sections within chapters. The unique material that they found was most helpful and became a significant part of the overall text.

Finally, we would be remiss not to mention all the visitors who donated photographs of the pageants, the queens, and the parades through the years. The society's collection gave our volunteers the means to flesh out the past years and provided an intimate glimpse into the local festival that grew to become Lombard's own Lilac Days.

Tom Fetters (Editor)

Unless otherwise noted, all photographs are from the collection of the Lombard Historical Society, 23 West Maple Street Lombard, Illinois 60148.

INTRODUCTION

Lombard, a village 20 miles due west of Chicago, was originally settled as Babcock's Grove, an area both east and west of the DuPage River. The DuPage is a small stream but typical of many in the western prairies that drained the slightly undulating land by following shallow depressions in the topography. The area was linked to Chicago by St. Charles Road, an improved road little better than a trail, that ran west to the town of St. Charles on the Fox River, some 40 miles west of Chicago. St. Charles Road remains a well-used county road running through downtown Lombard and only a half block north of Lilacia Park.

Ralph and Morgan Babcock were the first to claim the land on both sides of the DuPage River where Lombard and Glen Ellyn are situated today. The Black Hawk War, fought in western Illinois, ended in 1831 and effectively removed the native population from northern Illinois to west of the Mississippi River. The result was a widespread migration of pioneers that surged westward to fill the open land as it was vacated.

There were several reasons that people settled among the groves of trees scattered along the prairie. Among these were the fear of prairie fires, the need for a source of wood to build homes, and the mistaken belief that the soil under the prairie grass could not sustain crops. Moving through the region in the early 1830s, the Babcock brothers only stayed a short while before traveling on farther west to establish new settlements. Babcock's Grove was just one of many settlements west of Chicago that began in the 1830s. By 1849, the community found itself located on the first railroad to be built in Illinois, which had regular service to and from Chicago. During the next 20 years, Babcock's Grove became an attractive alternative to living in the crowded neighborhoods of Chicago and was also a popular location for day trips to the "country."

Following the Civil War, the town of Babcock's Grove went through a "re-branding." Based on its handy location to the city and the well-established public transportation, prominent settlers from Chicago took an interest in changing the sleepy community into a fashionable town in which to raise a family. Among them were Josiah Lombard, who funded the development of the downtown area from that of a farming community to a bedroom community; Gen. Benjamin Sweet, a local hero and former commandant of Camp Douglas—the notorious prison camp in Chicago for captured Confederate soldiers; and William R. Plum, a former telegrapher for the Union Army and now a Chicago attorney with Yale Law School training. In 1869, these three new residents encouraged the citizens of Babcock's Grove to incorporate as the Town of Lombard. Of the three, Col. William Plum made the most lasting impression as the benefactor of both Lilacia Park and the Helen M. Plum Memorial Library. [The Town of Lombard was reincorporated in 1903 as the Village of Lombard.]

Today visitors to Lombard can find many historic areas to remind one of the pioneer days. There is the Sheldon Peck Homestead, a museum operated by the Lombard Historical Society, which is the oldest house in the village and once was a stop on the Underground Railroad. Across the street from the Peck homestead is the main line of the Union Pacific Railroad, which operates

over the original right-of-way of the Galena and Chicago Union Railroad, the first railroad in Illinois. This line opened the western counties of Illinois with transportation from Freeport and Rockford to the suddenly vibrant halls of commerce in Chicago. In downtown Lombard, one can find the Maple Street Chapel, the original building of the First Church of Lombard, a classic Gothic Revival building with a tall, white bell tower and steeple on the corner of Maple and Main Streets. On St. Charles Road at Park Avenue, the old Lombard Hotel still stands but has been modified to other uses as a commercial structure for shops.

Our interest is drawn to Lilacia Park, an area purchased by Colonel Plum to build his house and where he later cultivated gardens of lilacs drawn from many sources. This book tells more about Plum, his activities during the Civil War, and how he became Lombard's best-known citizen in his latter years.

Plum's avocation in studying lilacs grew to become a heritage gift to the Village of Lombard and then, under the care and design of Jens Jensen, was carefully designed to become a horticultural masterpiece. Lilacia is now Lombard's most popular park and the source of Lilac Time influence on the community. The acquisition of this gift of Lilacia led to the formation of the Lombard Park District, which has preserved Lilacia Park through careful conservation and loving care. Other civic organizations associated with Lilac Time are the Lombard Area Chamber of Commerce and Industry, which sponsors the Lilac Ball; the Lombard Junior Women's Club, which sponsors the search for the Lilac Queen; the Lombard Lilac Festival Parade Committee; the Lombard Service League, which provides the tiaras for the princesses as well as the queen's crown; and the Lombard Garden Club. The Village of Lombard provides guidance and support for the Lilac Time activities.

One

WILLIAM R. PLUM
A MAN FOR ALL SEASONS

Lilacs were not native to the DuPage River area or to North America. They were popularized in Lombard by William Plum, who had moved to Lombard after the Civil War. Born in Massillon in Stark County, Ohio, on March 24, 1845, he was the youngest of 10 children of Henry Plum and Nancy North, who had married on October 11, 1835. When he was two, his parents moved to Cuyahoga Falls, Ohio, north of Massillon, and young William often explored the Cuyahoga River that ran through the town. He enjoyed the beauty of the giant chestnut trees and the white ash that grew naturally in the area.

Fifteen-year-old William taught himself Morse code and learned the skills of telegraphy. A year later, he was hired as a telegrapher for the Cleveland and Pittsburgh Railroad. The Civil War began in April 1861, and Plum tried to enlist the next year. The youth was clearly too small for the regular military units, and he was turned down. Later he was accepted into the U.S. Telegraph Corps, a section reporting to the president.

After the war, he earned a law degree from Yale and then married Helen, whom he met while in Connecticut. They moved to Chicago, and the couple bought the Widow Harris property in Lombard. The land had a small dwelling on high ground on Park Avenue, and behind it, down the hill to the west, there was a barn. Some say that the area was an "uncouth plot of ground overlooking a dreary slough." The small house was remodeled to provide a new, larger, and more modern home.

Plum established his own law practice and worked at law for some 30 years until 1900. The title of "Colonel" was given to Plum as an honorary distinction. In the first years of the 20th century, the retired Colonel Plum and his wife traveled throughout the United States, Canada, Mexico, and many of the countries of Western Europe. Plum wrote both fiction and nonfiction books, and owned a great law library and America's largest private collection of books about the Civil War.

The Plums' house and grounds were willed to the Village of Lombard with the wish that the house would serve as the library. The current library, still on the original Plum property, is known as the Helen M. Plum Memorial Library. The garden grounds became the start of the Lombard Park District and at first were ignored as a cultural location. But this was not to last long.

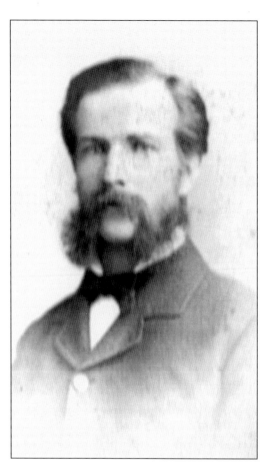

After the Civil War, William R. Plum headed to Connecticut and went to Yale Law School in New Haven. He worked his way through school as manager of the New Haven Telegraph office and saved more than $500. Admitted to the bar in 1867, he married Helen Maria Williams of Ledyard, New York, and the couple moved west to Chicago. They purchased a 2.5-acre lot at the corner of Park Avenue and Maple Street in Lombard. They had their photographs taken at the Brand Studio on Wabash Avenue in Chicago in 1880 when Colonel Plum was 35 years old. (Both, courtesy of the Helen M. Plum Memorial Library.)

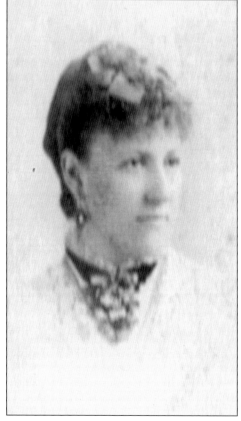

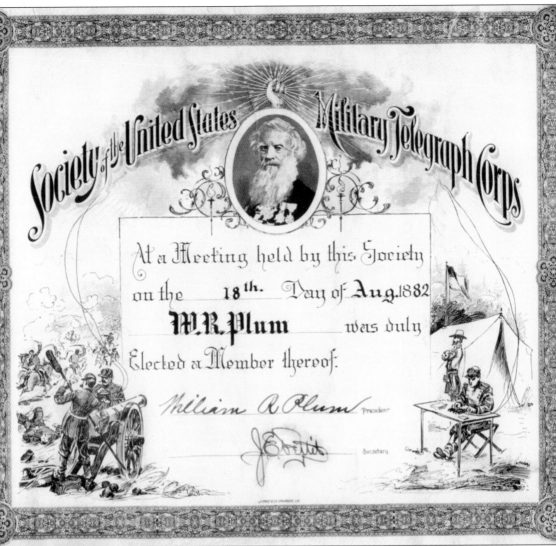

This certificate from the Society of the U.S. Military Telegraph Corps was presented to William Plum in 1882, seventeen years after the war had ended. He had been given a number of risky assignments in the field, especially in Kentucky, while working as a telegrapher to transmit the army's critical messages directing field movements of the troops. Many of Plum's messages went directly to Pres. Abraham Lincoln in Washington, D.C. (Courtesy of the Helen M. Plum Memorial Library.)

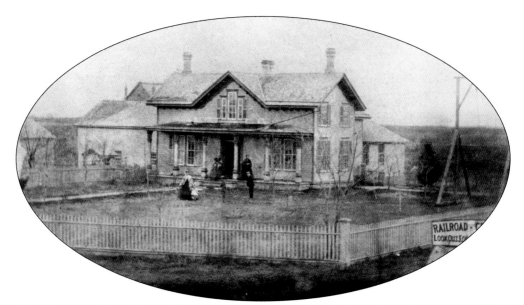

The Plums' neighbors, Newton Chapin and his wife, Caroline, lived on the southeast corner of Park and Parkside Avenues. Newton Chapin had greeted the Plums the first day when they moved into the small Widow Harris farmhouse. He also gave Helen Plum a short tour of the town in his boat, rowing the large pond just east of the Plums' purchase and along the stream under the railroad. This view of the Chapin house shows the warning to "Look Out for the Cars" on the railroad on the corner and the original long porch on the north side.

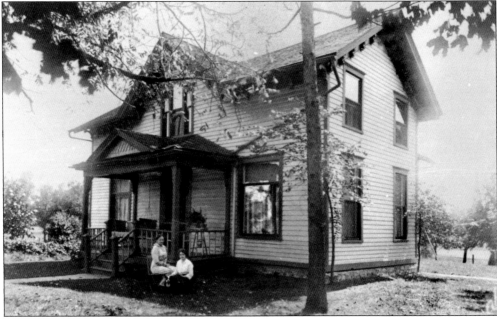

The Chapin house was later remodeled with a smaller porch at the front door and new gutters, as well as special trim under the eaves. Not much later, Colonel Plum remodeled his house to replace the small Harris house that had been crowded with furniture the Plums had brought from the east. The Chapin family and other neighbors on Maple Street soon made Helen Plum welcome, and she enjoyed the small community and its social advantages.

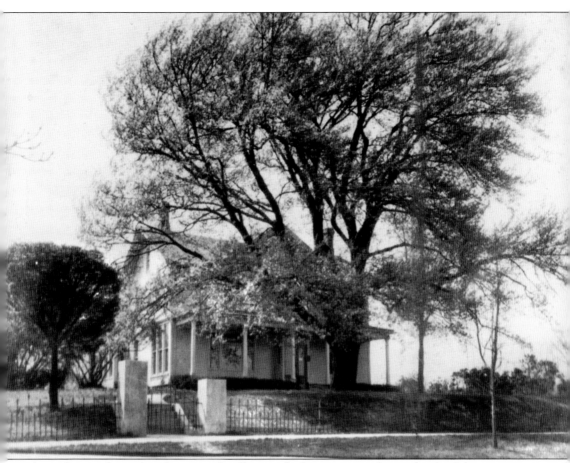

An early view shows that the original walk up to the house was on the south side of the property and was protected by two cemented brick columns of unequal height and a slender iron fence with a gate. One had to climb four steps to walk up to the porch to ring the bell. The chimneys had the original, wide, decorative construction at the top.

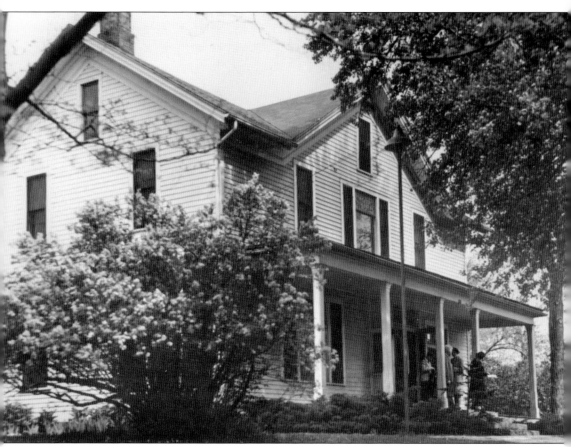

A later view shows several modifications of the Plum house. A huge flowering lilac bush obscures the southeast corner of the house on a bright Sunday morning in late April. Several neighbors have stopped by to talk with Colonel Plum about his garden hobby. After his death, the house was transformed into the Lombard Library. The current building on Maple Street is named for his wife as the Helen M. Plum Memorial Library.

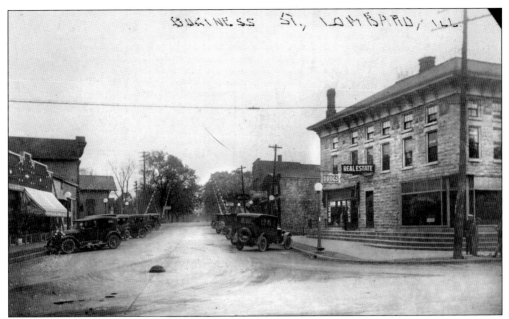

Looking south from the heart of Lombard at Park Avenue and St. Charles Road, Park Avenue is flanked by the Lombard Hotel on the right and with the drugstore and by small shops on the left, which end at the Chicago and North Western Railway depot. The crossing is now protected with gates controlled by a gate man. Farther south, Park Avenue is bracketed by the tree-filled Plum property on the right and the Chapin property at the left-hand corner, with a treescape beyond.

Looking north from Colonel Plum's house toward St. Charles Road, a boy and his father are captured by the photographer. A new brick store is on the east, just south of the Chapin house, on the corner of Parkside Avenue. The tracks are protected with the pneumatic gates controlled by a gate man, who rests in his gatehouse on the south side of the tracks, seen at the left. Some of the small shops on the east side of the street are also shown.

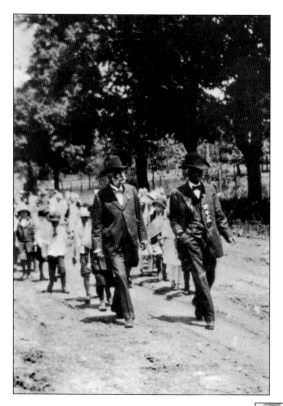

On Memorial Day 1910, Colonel Plum (left) corralled a number of young children for an impromptu parade down the unimproved surface of Main Street. Few of them knew that Plum had been born in Ohio on March 24, 1845, and had served his country during the Civil War. A Mr. O'Neill, the last Civil War veteran in Lombard, marches along with him.

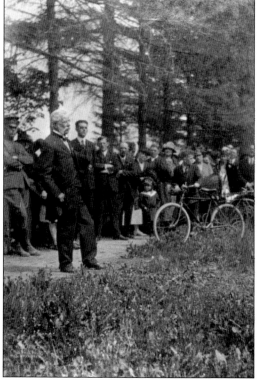

Later the same day, Colonel Plum addressed the gathering of local Lombard residents at the Lombard Cemetery on Main Street. He gave a stirring oration about the campaign to defeat the Confederate troops that had faced the Union corps. He had rapidly reported, by telegraph, the conditions in the field of battle to the officers waiting to direct the troop movements.

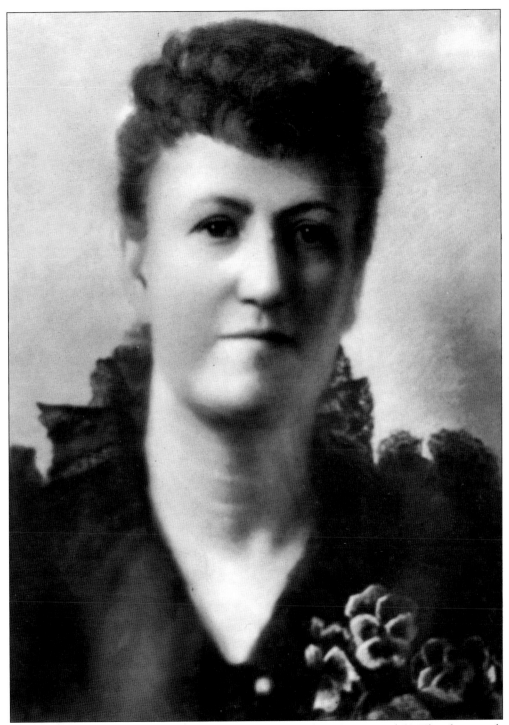

This studio print was taken about 1895, probably when Helen Plum turned 50. The photograph captured her in a fairly stiff pose, typical of photo studios at the time, which often employed iron braces on the chair back to assure no movement during the exposure. (Courtesy of the Helen M. Plum Memorial Library.)

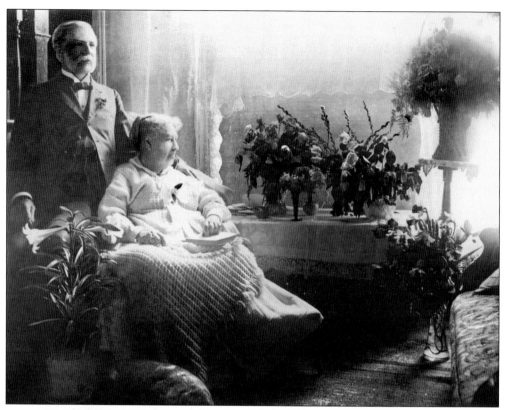

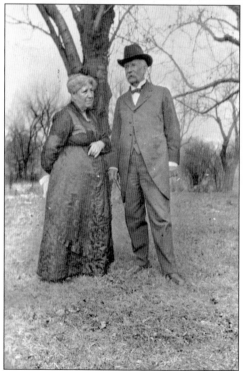

Col. William R. Plum and his wife, Helen Maria Plum, pose in the front room of their house on Park Avenue in Lombard on their 50th wedding anniversary, perhaps thinking of their travels to all of the 48 states as well as 17 European countries in that time. Plum and his wife spent five months in Savannah, Georgia, and then a short time at Parris Island, South Carolina, near Beaufort, before she passed away on March 25, 1924.

In late fall, Helen and William Plum posed for this photograph on the high ground along Park Avenue with their "Lilacia" stretched out behind them. During a visit to the Lemoine Lilac Gardens, in Nancy, France, in 1911, they purchased two French lilac hybrid cuttings: one was a pure white, and the other was a double bloom in light purple. The two cuttings were planted behind their house that same year and became the start of their Lilacia garden.

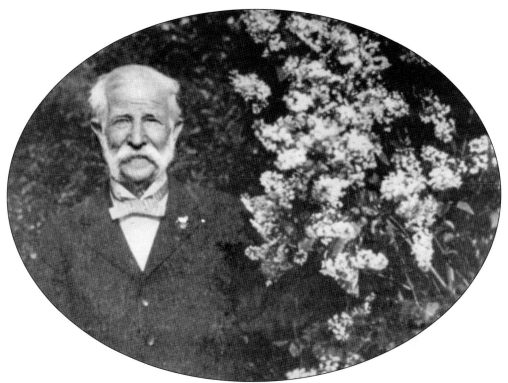

Colonel Plum was asked to pose with the lilacs that he loved so much. A professional print, this is an attractive setting for Plum, although the lilacs cannot be identified by genus. With these lilacs in full bloom, Colonel Plum, looking dapper with a lilac-colored bow tie, stands in his garden in full sunlight on a warm day in late April.

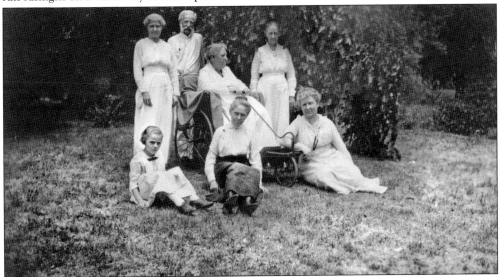

Colonel Plum stands behind Helen's wheelchair as the couple enjoys a visit from several of their siblings and at least one niece. Could it be Helen's mother standing at the right? It remains a question for the ages. This seems more like an early summer day with everyone dressed in white and enjoying the suburban weather at Plum's Lilacia behind his house on Park Avenue.

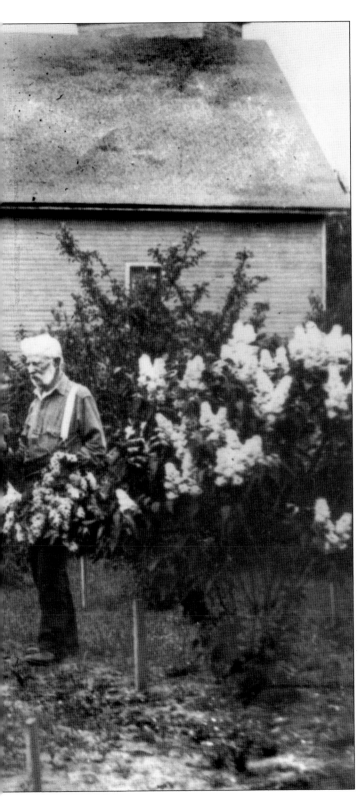

What is so rare as a day in May surrounded by lilacs of every hue and shade? Colonel Plum tends to the plants near his garden house, with hundreds of varieties found on their travels and many more varieties from the Lemoine Lilac Gardens. The manager of Lemoine Lilac Gardens wrote Plum in 1925 that "nobody grows in Europe a complete collection of lilacs. You have probably the largest in the world; more than the Arnold Arboretum and the public parks of Rochester, New York."

21

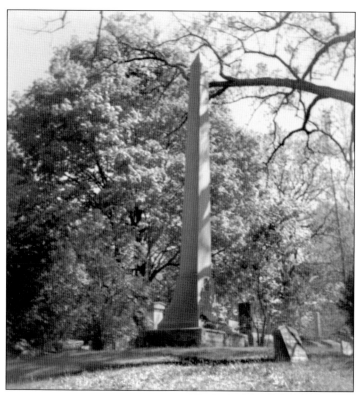

Col. William R. Plum and his wife, Helen Maria Plum, rest here beneath this obelisk in Cuyahoga Falls, Ohio, in the Cleveland area. Colonel Plum had been raised in the Cuyahoga Falls area, and it was this area he called home. Helen died in 1924, and three years later, William Plum died on April 28, 1927. With no children, the remains of the Plums were sent east to Ohio for interment.

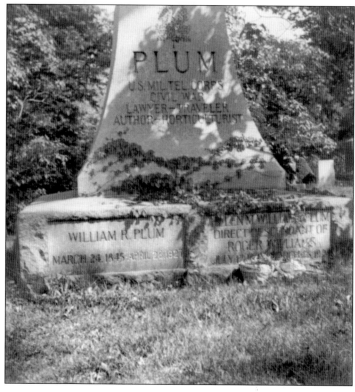

Two

JENS JENSEN AND
LILACIA PARK
A MAN AND HIS VISION

William R. Plum donated his former home as a public library in 1927 and included his carefully cultivated lilac garden and an additional $25,000 to create the first public park in Lombard. Plum's property and garden had already become famous in Northern Illinois. All that was needed to transform the garden into a public park was a vision. The original name of the new park was Plum Memorial Park. Soon, however, the popular name for Plum's garden, Lilacia, overtook the assigned name.

The newly formed Lombard Park District Board, headed by William Ralph Plum, the nephew of Colonel Plum, solicited plans from well-known landscape architects. In May 1928, the board voted to accept the design of Jens Jensen. The *Lombard Spectator*, in its May 28, 1928, issue, commented that Jensen "has made several visits to Lilacia and has become deeply interested in the estate and the novel features it offers in the wonderful lilac gardens."

Jensen, born in Denmark in 1860, was hired to design the West Park System of Chicago and became the principal designer of the Garfield, Douglas, and Humboldt Parks. Later he became general superintendent of the Chicago Parks. His greatest achievements included the Garfield Park Conservatory and the design for Columbus Park. Jensen's aversion to the politics of the city led to his turning to private commissions from wealthy homeowners on the North Shore.

Between 1927 and 1929, the Lombard Park District Board voted to acquire an additional 5 acres of land along Parkside Avenue for $67,000. This land was to be incorporated in the Jensen design for Lilacia Park. The park district renovated Plum's coach house for use as an office for Jensen and for holding the regular meetings of the park district board.

Lombard quickly took to the idea of having a well-designed public park by a prominent landscape artist. Jensen was introduced to the citizens of Lombard at a special presentation on May 24, 1929, at Lincoln School, a three-story brick edifice on St. Charles Road. Plans were made for a community-wide celebration of Lilac Time the following year, and, at the same time, several citizens formed the Lombard Lilac League to ensure that the proposed programs of 1930 would be a success.

The park district board, afraid they could not afford Jensen's services, asked what his fee would be to complete the work. He gave them a wrinkly smile and asked if $600 would be too much. Jensen clearly wanted the job for his personal pleasure, and he was hired that evening.

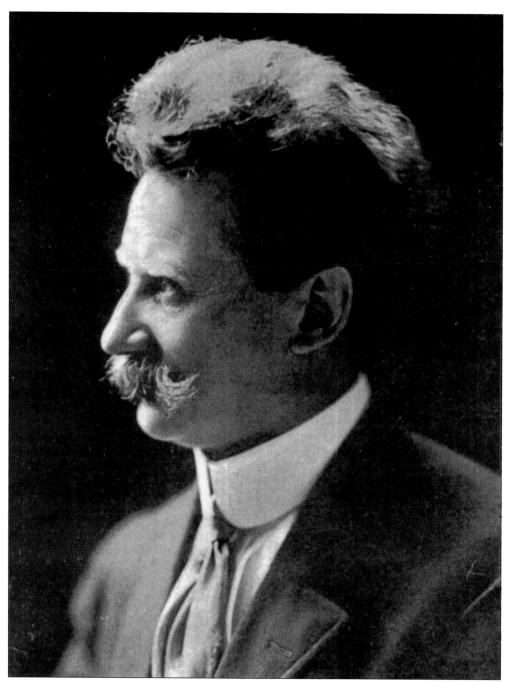

Jens Jensen was born on September 13, 1860, in Denmark and was educated in Danish and German schools. He immigrated to Chicago in 1884, took a position with the West Parks Administration, and was assigned to be superintendent of Humboldt Park. He resigned in 1900 and began to practice landscape architecture until 1906, when he returned to the West Parks as landscape artist and general superintendent for three years. (Courtesy of the photograph collection of the Chicago Historical Society.)

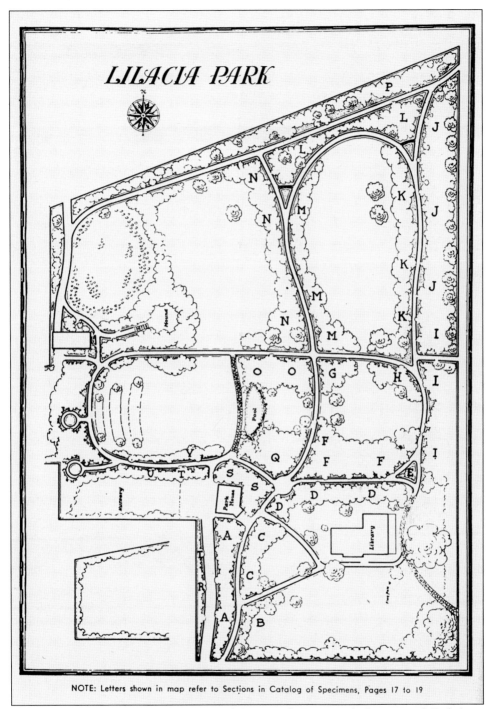

NOTE: Letters shown in map refer to Sections in Catalog of Specimens, Pages 17 to 19

Jensen's original plan for Lilacia Park looks north from Maple Street on the bottom, with Park Avenue along the right side and Parkside Avenue and the Chicago and North Western Railway tracks at the top. The Plums' house, by this time the Lombard Library, is at the bottom right, and the coach house, now the Park Administration building, is at the end of the drive from Maple Street into the new park. The fishpond is at the center of the map.

25

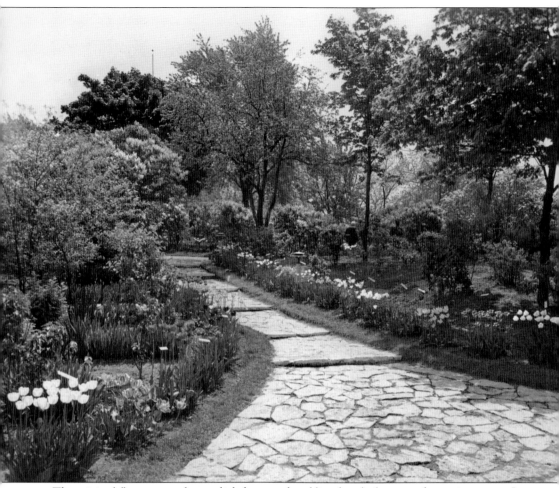

The original flagstone path was slightly curved and lined with the second most important Jensen feature, Dutch tulips. Over the following years, the flagstones on the path were replaced with fine gravel that gave greater access to the contours of the landscape. Jensen's interest in "French curves," in place of rectangular outlines for paths and gardens, is evident here as the walk rises slightly as it curves to the left.

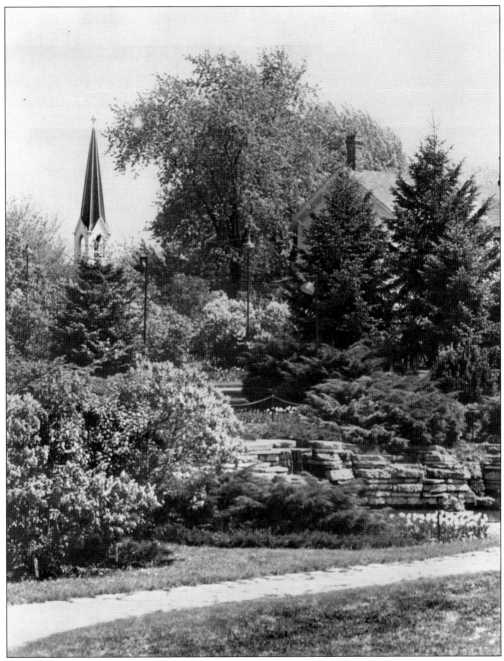

Jensen's designs almost overpower this setting. The flagstone path leads one past the limestone bank with the waterfall cascading into the fishpond. A brick wall provides a horizontal influence. "Mother's Tree," named for Helen Plum's mother, looms up in the center and is bracketed by the steeple of the First Church of Lombard and the Plum house, which now served as the village library. Seen in May 1930, it is clearly Lilac Time as the bushes display their finest blossoms.

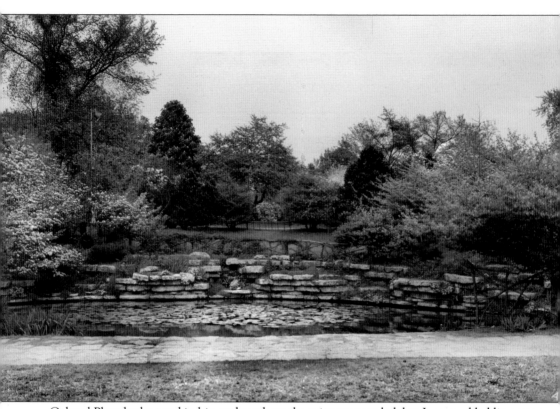

Colonel Plum had a pond in his garden where the rainwater settled, but Jensen added limestone rocks and an overlook for his redesigned reflecting fishpond graced with lily pads. The tree at the upper left is a horse chestnut in the northeast section. Nearby, in the "Oak Meadow" area, there is a collection of eight of the nine indigenous oak trees of Illinois, as Jensen preferred to use native plants in a more natural setting.

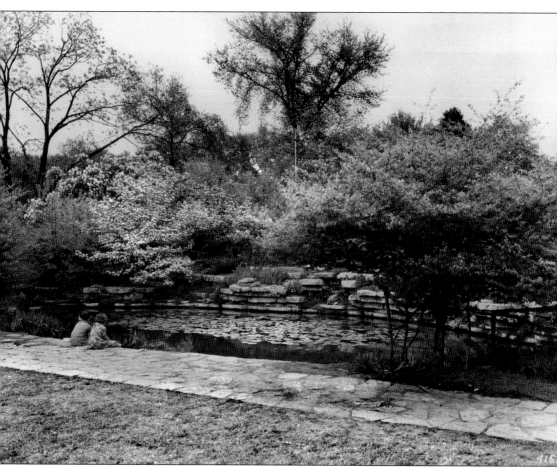

The horse chestnut tree leans in to watch the two girls who are lost in conversation and pay little heed to the movement of the branches. Sitting on the flagstones that line the lily pond, they are far, far away from the commercial center of town, only a half block north and across the tracks, on St. Charles Road. Jensen used the elements of the Midwestern landscape to offer mystery and surprise around every curve.

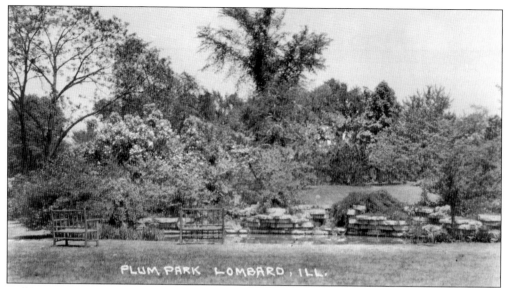

Still known as Plum Park, this area at the east end has the limestone bank, the tumbling falls, and the gazing ball seen at the right center. The horse chestnut tree was placed by Jensen to provide a vertical element to the design. The designer also provided wooden benches for contemplation of the landscaping, but these were later removed.

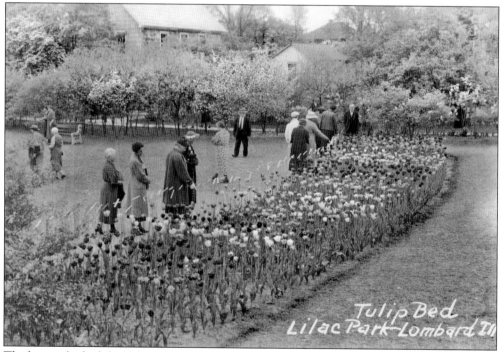

The large tulip beds brought a splash of color to the southwestern side of the park. The buildings are those of neighbors along Maple Street, who enjoyed the conversion of the farm to a specialized park. The beds, arranged with an attractive fencing, guided visitors along the beds and discouraged any tiptoeing through the tulips.

30

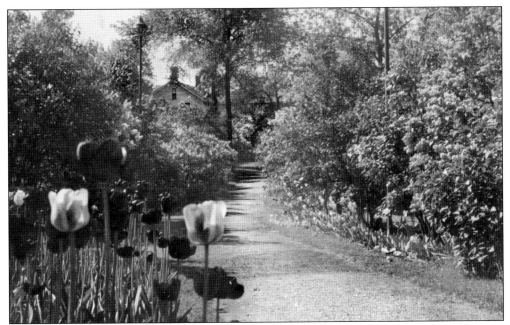

Looking south from Parkside Avenue toward the Plum house on Park Avenue, the differences between the powerful colors of the tulips contrast with the muted shades of the lilacs. The tulips begin to bloom in late April and the last emerge in mid-May, nicely bracketing the three-week bloom of the lilac bushes.

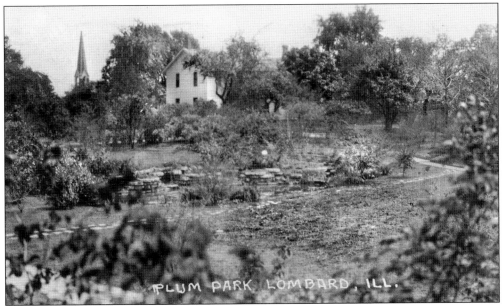

The late Colonel Plum left some 1,100 lilac plants in the private garden, first known as Plum Park. Initially only 150 plants were fully identified. Jensen had the lilacs replanted in 1929 in new positions to fulfill his plan for the park design. The *Saturday Evening Post*, a weekly magazine, carried an article on Jensen and mentioned his idea of man's influence on nature, "a landscape architect, like a landscape artist, can't photograph; he must idealize the thing he sees . . . a reproduction is a reproduction no matter how fine and noble the model is."

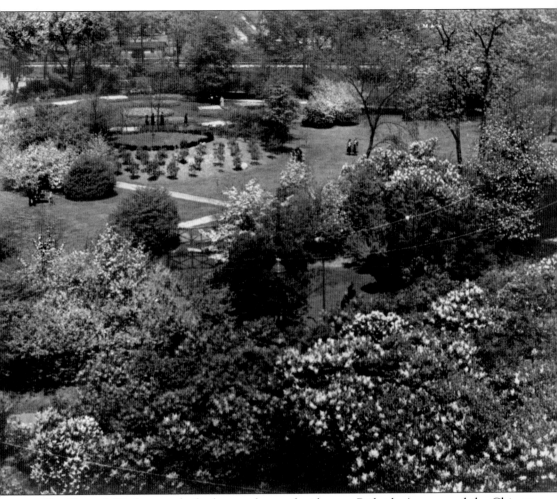

The Council Circles were built close to the north side near Parkside Avenue and the Chicago and North Western Railway tracks in the original Jensen design. Sections of downtown along St. Charles Road can be seen in the distance. The circles were altered early on as the park district sought to make some areas more useful for lilac display.

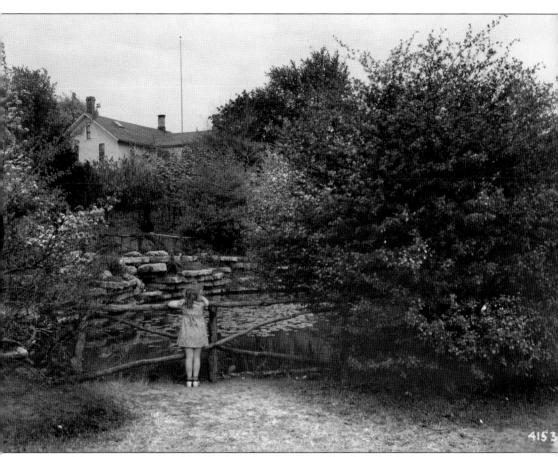

Surrounded by a forest of giant lilac bushes, this five-year-old is kept back from the fishpond's water by the rustic fence that graced the early park design. Looming over the pond is the second story of the rear of the William and Helen Plum house on South Park Avenue. Jensen had begun his work in July 1928 after agreeing to a stipend of $600, as well as living accommodations for he and his wife, Anne Marie, at the Plum house. The couple moved in, and Jensen's wife worked to organize the library books and to open the library for two hours a day, four days a week.

These two views show the jerkinhead architecture of Plum's coach house. They date from 1930 when the park was still referred to as Lilac Park. Jensen had visited Colonel Plum's garden and the later Plum Park a number of times before he submitted his design. The property was originally 2.5 acres filled with lilacs, trees, and flowers that Colonel Plum had begun collecting in 1911 after retiring.

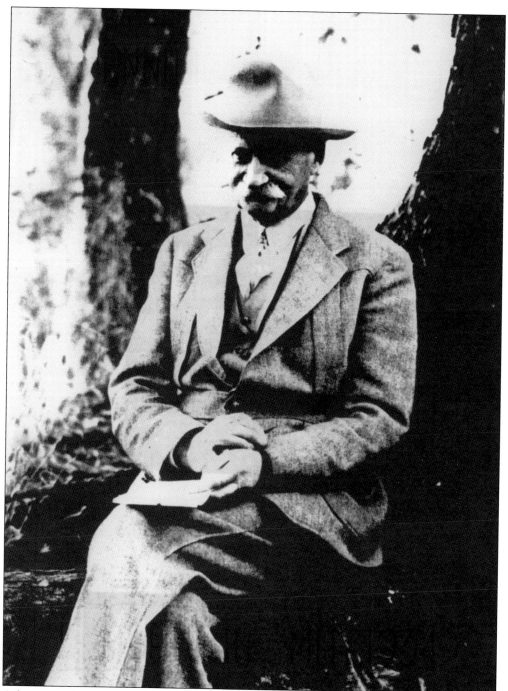

A few years after completing Lilacia Park, Jensen was found contemplating his notes for designing a new landscaped park. His dapper apparel makes one wonder if this was his normal dress for a day in the field. A stiff collar, tightly knotted tie, and a weskit under his jacket certainly suggest that he was not going to get down on the ground to measure details. He has wrinkles near his eyes, which suggests that time was gentle, but unrelenting to his appearance. (Courtesy of Morton Arboretum, Sterling Morton Library.)

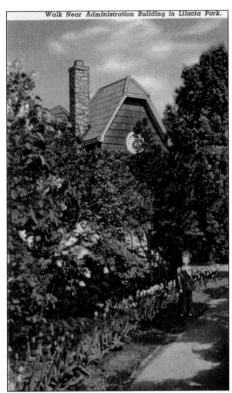

Walk Near Administration Building in Lilacia Park.

Burt Bowlby knew how to frame a photograph. At left, he has a young boy stand by the tulip bed surrounded by blooming lilac bushes, while the jerkinhead style of the Administration Building on the park's south side looms over the area. Note the landscape view with the bushes and tree setting off the Administration Building. Now study the similar vertical view that accents the sharp angles of the building with greater emphasis on the lilacs and tulips. The last view was used by the park administration for a pamphlet.

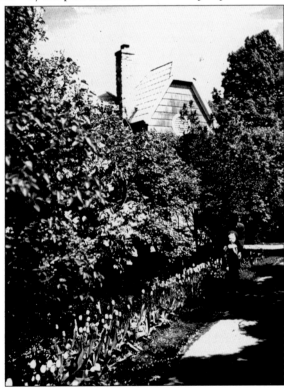

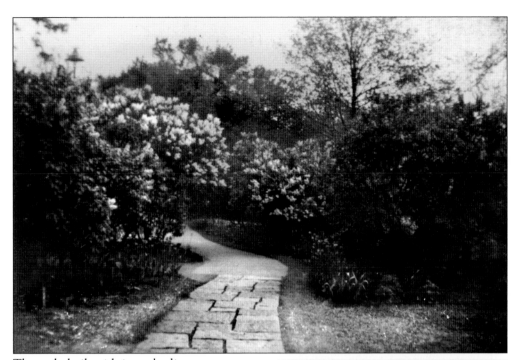

The path, built with irregular limestone sections, makes the visitor wonder what lies around the bend. Jensen created what he called his own "Prairie Style" landscape designs that combined subtle beauty and conservation. Jensen was considered to be "dean of American landscape architecture," according to the *New York Times*.

Jensen used limestone screenings for the path along Parkside Avenue, which paralleled the railroad. No mystery here but plenty of tulips and lilacs. Originally crushed stone paths were to wind around the park grounds, although later this was modified to limestone fieldstone for the paths.

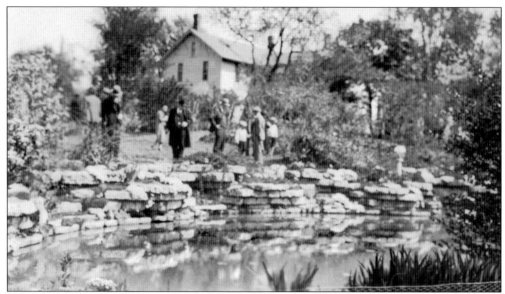

Built into the limestone bank, a small waterfall tumbled over the rocks and into the lily pond. Note the former Plum house in the eastern part of the park. It was now serving as the Helen M. Plum Memorial Library. The gazing ball sits on the south end of the limestone bank at the right. Jensen's plan included a beautiful fishpond set in the center of the park with lilies located in the center of the pond. Above the pool, a greensward stage area would be set in the natural trees, and, below, a large level lawn spread out on which an audience could be seated.

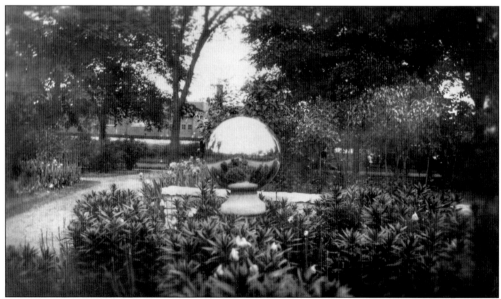

Jensen cleverly set a large gazing ball just south of the limestone bank of the reflecting pond. Seen here in 1930, the gazing ball was an attraction in itself, but it also drew attention to other areas in the park. The gazing ball was later removed from the park to avoid problems with high-spirited youths who found the sphere tempting as a tossing ball.

Children enjoyed walking along the path bordered by the weeping or white mulberry trees that Jensen placed on the south side of the park. These trees provided a contrast to the lilacs and oaks, as well as the horse chestnut tree.

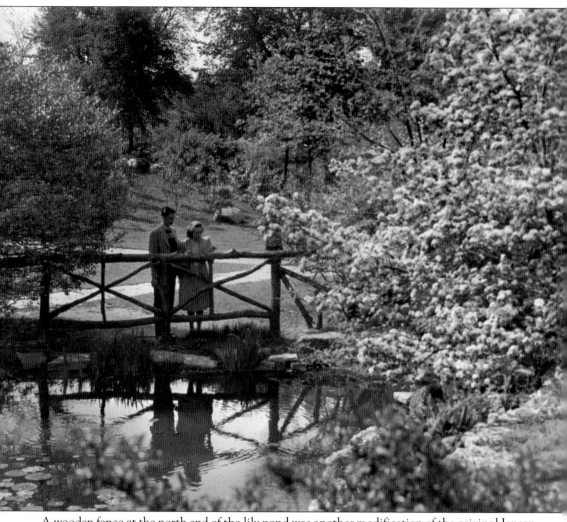

A wooden fence at the north end of the lily pond was another modification of the original Jensen plan and was evident in 1937 as the park district adjusted the landscape to fit the new needs.

By May 1937, the park was well established in its faithfulness to Jensen's original plan. The designer had stipulated that large open spaces be set aside for a play of sunlight and shadows within the park. Note the natural use of vines to direct traffic within the park along the prepared pathways.

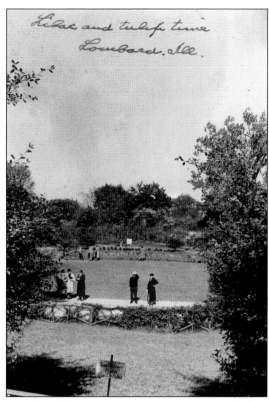

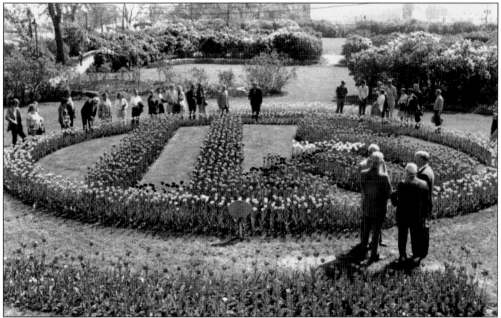

Jensen knew that the addition of tulips would provide an appealing contrast to the pale colors of the lilac bushes, which bloom at about the same time. He imported more than 40,000 bulbs from Holland for the park, and every year some 25,000 tulips still blossom in Lilacia Park. In some areas, Jensen planted beds of native wildflowers for contrast.

The Chicago and North Western Railway tracks run across the midsection of this photograph of the north side of Lilacia Park. The tulips are gone, but a designed placement for the small bushes show the Jensen design that distinguished the early years of Lilacia Park.

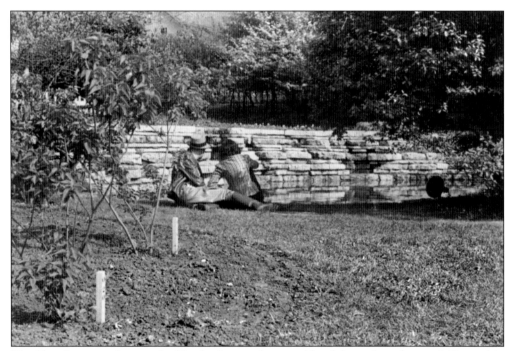

The Plum house peeks over the lilac bushes on the east side of the park at the pond. Dressed in sporting clothes, this couple is not restrained by the rustic fencing that was installed later. Note the white stakes with notations on the species of the new bush plantings next to the photographer.

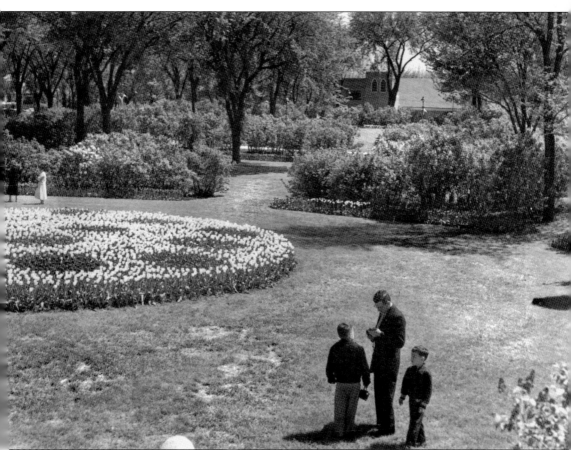

Impressed with this massive tulip display, the father checks over his camera as the older son watches with his own Kodak dangling from his hand and his younger brother begins to walk off to the west. In the background is the church at the corner of Park and Parkside Avenues near the Chicago and North Western Railway station.

Two postcards from the early 1950s, selected from the museum's Lilacia Park collection, show several couples pausing on some of the benches to contemplate the flowering trees and bushes, as well as the other plants that are in full bloom. The photograph below shows one of the creative six-pointed star designs used to take advantage of the bright yellow rays and the brilliant crimson of the center circle. In the background is commuter parking along the Chicago and North Western Railway tracks looking northeast.

44

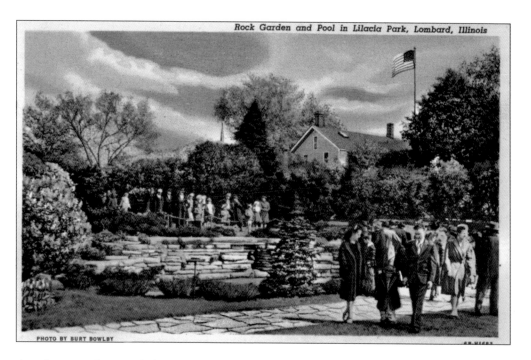

Another pair of postcards from the early 1950s shows the crowd wandering around the numerous pathways on the east side of the park. The Helen M. Plum Memorial Library sports a flag high above the remodeled house that now has a skylight in the roof to direct more light into the room. Pictured below, a new queen is bracketed by two princesses on either side as they pose above the fishpond just after the coronation ceremony.

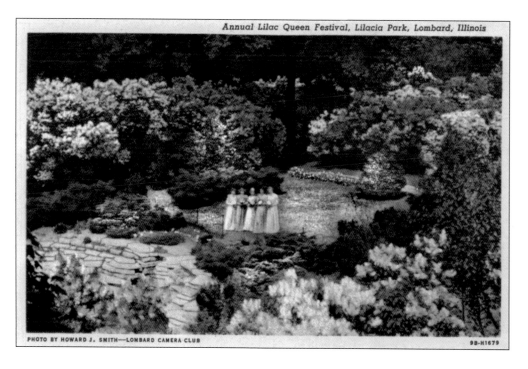

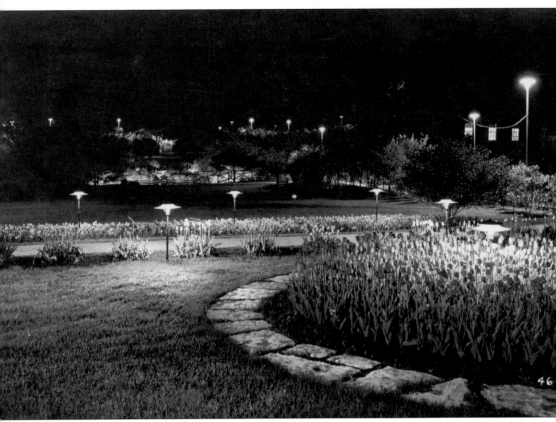

The park was illuminated with electric lights in the 1950s to allow visitors to see the lilacs and tulips in the evening hours. Strategically placed to get the most illumination along the pathway and overhead in some places, the nighttime views gave an alternative look at the Lilacia Park horticulture.

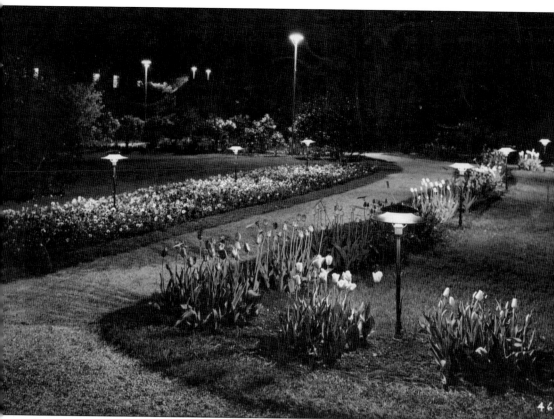

The coach house windows glow with welcome in the distance at far left as the curvilinear path wanders through the tulip beds. Now illuminated by the modern electric lights, a few tulips are still open in the direct light but are snugly closed in the indirect light away from the lamps. The response by the flowers is interesting to the late evening visitors who slow down to see the contrast.

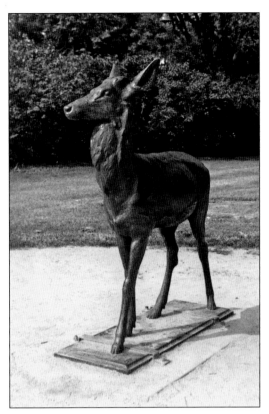

Rastus is the best-known feature of Lilacia Park's western end. The deer was cast at a Pennsylvanian foundry in 1888 for the residence of A. H. Andrews at the southeast corner of Main Street and Parkside Avenue, a corner later to be home to the DuPage Theater. Fire destroyed the Andrews house in 1926, and Rastus was moved to Lilacia Park as an integral part of the design. Still there after more than 70 years, the deer is more than 130 years old.

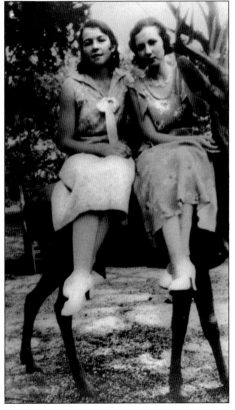

Rastus became popular in the ensuing years and was prized as the location for a photograph while sitting on the deer's back. Here Dorothy Hopkins (left) and Marion Santschi enjoy the tradition at Lilac Time in the early 1930s. Today it remains a tradition to stop and see Rastus during a visit, as the deer has become emblematic of Lilacia Park.

Three

1930 TO 1936:
THE BUDDING LILAC TIME

The new Lilacia Park was indeed a jewel in Lombard's crown, but it was not known outside of its own village. In 1929, an idea was born. The Lombard Lilac League was formed to attract public interest in the new park and to guide the development of the public activities set to commence in 1930. The rose festivals on the West Coast had proven to be popular, and the league felt that the beauty of Lilacia Park could be a fitting showcase for Lombard.

The town would stage a festival with a pageant and a parade, and would feature the crowning of a queen to be held in Lilacia Park at the height of the bloom. Rules for the selection of the queen were formulated. The entrants had to be between the ages of 16 and 24, unmarried, and a resident of Lombard. Ballots could be purchased to vote for the most popular girl, and the winner, with the highest number of votes, would be proclaimed queen of the Lilac Festival. These ballots were printed and distributed to businesses throughout the town.

The local paper, the *Lombard Spectator*, heavily promoted the contest and regularly reported the current standing of the candidates as May 17 approached. Even some of the Chicago papers featured articles on the new festival and the search for a queen, as well as flattering descriptions of Lombard and the new Lilacia Park. Exhibition posters by famed poster artist Charles Medin went up all over the town and in neighboring communities. The Chicago, Aurora, and Elgin Railroad added to the excitement by announcing that it would run a special train on May 17 to bring visitors to Lombard.

The newly formed Lombard Lilac League had no funds to purchase costumes and decorations for the pageant, and a call went out for help in fund-raising. The townspeople pitched in with donations and teamwork to assure the success of the pageant. As interest in the festival grew, a great number of people volunteered to take part in the pageant and work behind the scenes.

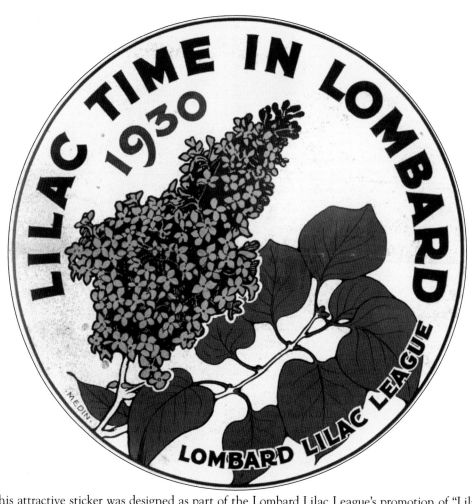

This attractive sticker was designed as part of the Lombard Lilac League's promotion of "Lilac Time in Lombard." The citizens of Lombard eagerly bought up these stickers to display in their windows, and they were soon seen decorating numerous automobile windshields. There was also a plan to promote the idea of every resident to plant lilacs on their own properties to nurture the culture of a "Lilac Town." Prizes would be awarded to those who planted the most lilac bushes. It was in large part due to the efforts of E. J. Costello, editor of the *Chicago Tribune* newspaper and a Lombard resident, that the Lombard Lilac League came into being. He was a visionary who saw the value of branding the village as the "Lilac Town" and suggested promoting Lombard as a vacation spot. In a speech entitled "Lombard: Its Future" made to the Lombard Lions Club in 1929, Costello shared his dream of promoting a lilac festival to be held in the town.

Charles Medin was one of Chicago's foremost poster artists and was a prominent Lombard resident as well. After studying at the Art Institute of Chicago, he went on to become the editor and staff artist of the *Illinois Central Railroad Magazine*, as well as performing freelance painting. The posters for the first pageant were a dual set depicting views of the lilac park and the much-loved home of the late Colonel Plum, which served as the village's library. The posters were planned to be displayed for a brief time in every one of the towns in DuPage County for the four weeks leading up to the Lilac Festival. Medin followed through with a series of posters for each of the pageant years. The original posters still exist, and reproduction copies have become popular collectors' items.

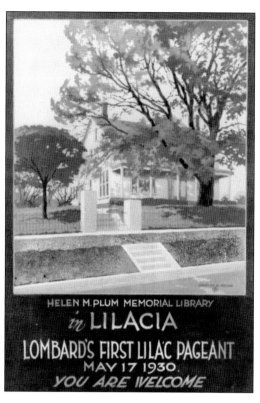

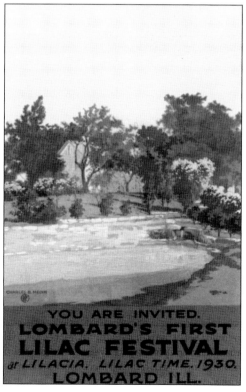

First Annual Lilac Festival 1930

Lombard Lilac League

LOMBARD LILAC QUEEN

BALLOT

Miss _____

White Ballots Good for Ten Votes

Pink Ballots Good for Eight Votes

Yellow Ballots Good for Five Votes

 130

The ballots were divided into three color categories: white, pink, and yellow. These ballots had a different point value for each category. For the flat fee of 5¢, the townspeople could vote for their favorite by writing her name on a ballot and dropping it off at the *Lombard Spectator* newspaper office or at the various businesses throughout the town that had voting boxes. There was no limit as to the number of ballots one might enter. Merchants would even give free ballots to customers who purchased more than $1 worth of merchandise. As quoted in the *Lombard Spectator* dated March 20, 1930: "Now the question to be decided by popular vote is: Who is the prettiest girl, the most popular girl, the one having most of 'It' in Lombard? A daily bulletin will be posted in a prominent place in the village showing the progress from day to day. Vote early and often!"

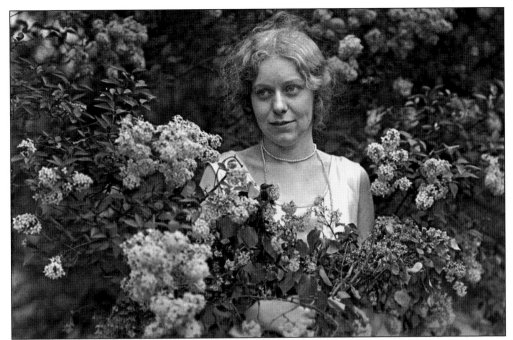

It was hardly a close contest. Adeline Fleege, daughter of Dietrich and Matilda Fleege, the proprietors of the Fleege Grocery Store, was an odds-on favorite and a front-runner the entire time of the contest. At the final count, Adeline Fleege had three times the number of votes received by her nearest competitor. The runaway winner became the first queen to reign over Lombard's first annual pageant.

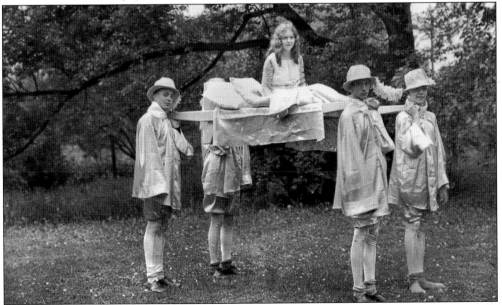

The pageant players formed a small parade that wound its way around and then into the park, with the queen being carried in state by her attendants on a flower-bedecked throne. Placed on her head was an intricate silver crown designed by Christia Reade. The historic crown was used for the subsequent queens' crownings from the first pageant in 1930 until 1936.

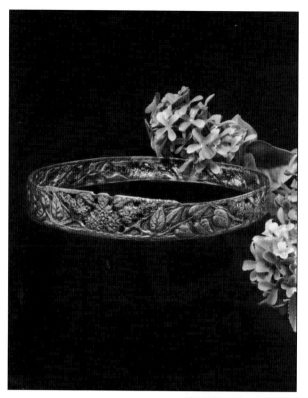

Christia Reade designed this intricate crown from silver spoons donated by the ladies of Lombard. The delicate workmanship included representations of Lombard's pride and joy: the lilacs themselves. Because of changing modern tastes, the coronation crown has been updated several times, and the crowns are retired to the Lombard Historical Museum, alongside the original. At Lilac Time these "crown jewels" are displayed by the museum.

Christia Reade was the daughter of Josiah Reade, who brought culture to the village by donating his own books to be used as the first lending library. She was a distinguished artist as a designer of stained glass, having trained in Europe for two and a half years. But where she really excelled was in designing exquisite pieces of silver jewelry. Her designs were prominently featured at the Chicago Columbian Exposition in 1893.

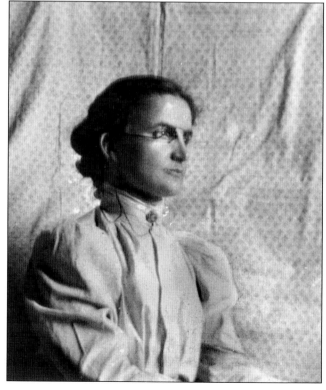

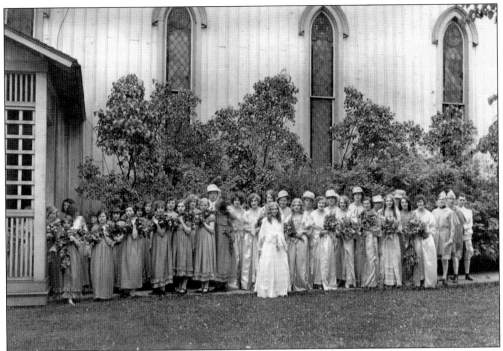

The play, entitled *Queen of the Lilacs*, was lengthy, consisting of three full acts involving a cast of 200 under the direction of Clara Baumann Pettee. The players paraded around the perimeter of Lilacia Park, erected a maypole, and sang and danced to the theme of medieval times. Shown here, Queen Adeline and the cast gather on the grounds of the Maple Street Chapel.

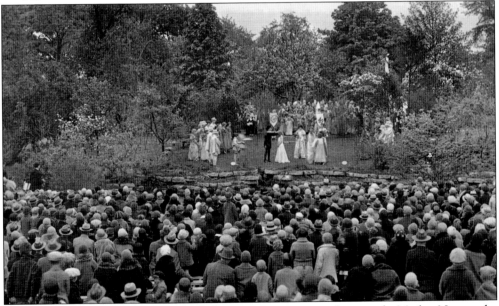

The pageant proved to be a hit with all those present except, unfortunately, Mother Nature; the play had to be cut before the third act. In spite of the unfriendly weather, hundreds and hundreds of townspeople and visitors braved the chilly winds and cloudy skies to attend. Every seat in the park was filled, with many people standing in the aisles.

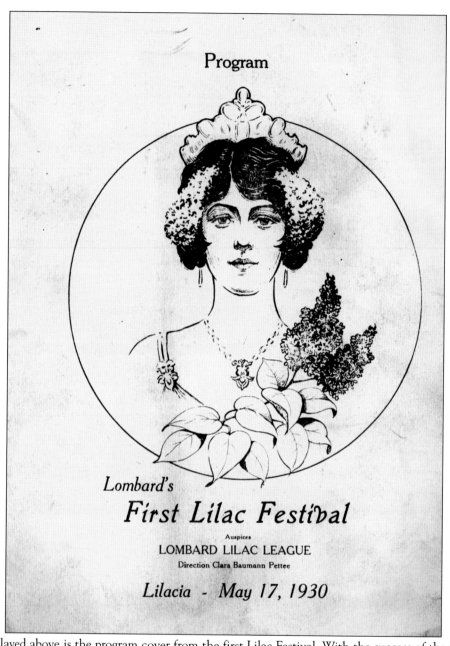

Program

Lombard's
First Lilac Festival

Auspices
LOMBARD LILAC LEAGUE
Direction Clara Baumann Pettee

Lilacia - May 17, 1930

Displayed above is the program cover from the first Lilac Festival. With the success of the first pageant now past, the villagers were eagerly anticipating the next year's event. By 1931, flattering reports of Lombard's beautiful lilac park had traveled to neighboring Midwestern states, with articles reported in newspapers as far away as Davenport, Iowa. The *Chicago Tribune*, as quoted on May 14, 1931, stated that "the lovely little park at Lombard, Illinois, 20 miles west of Chicago, is at this time one of the most beautiful in the United States." Lombard received exciting news that the Chicago, Aurora, and Elgin Railroad was taking part in the publicity and had offered free public displays in its main Chicago terminal to further interest in the 1931 pageant. This demonstrated to the townspeople the high esteem that was held outside the village regarding Lombard's annual festival.

The rules regarding the contest for Lilac Queen changed slightly this year, as the minimum age was raised to 17 years old. The 1931 winner, Alice LaFetra, was chosen, as before, by popular vote. She was a resident of the Westmore district of Lombard and served as one of the clerical workforce of the South Lombard Trust and Savings Bank.

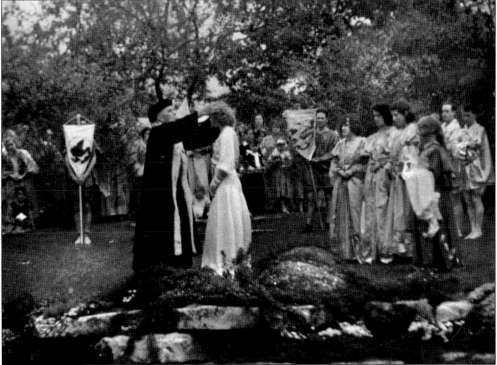

The pageantry of the festival opened with the ceremonial crowning of the Lilac Queen. The Lord Mayor of the festival did the honors of crowning LaFetra as the Lilac Queen while the court members looked on, and the children of the pageant cast entertained the audience by dancing and frolicking around the pond.

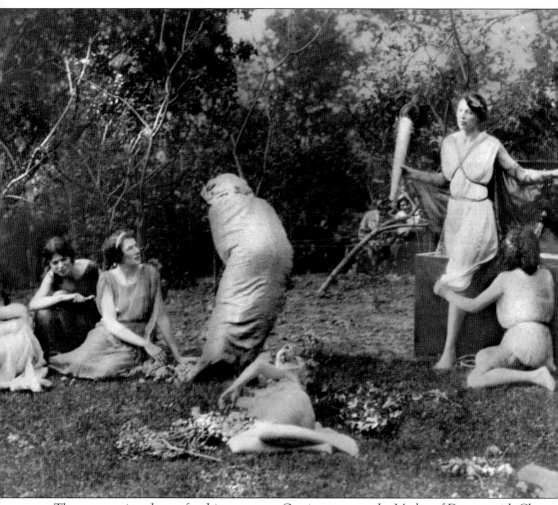

The presentation chosen for this year was a Grecian masque, the *Mother of Dreams*, with Clara Baumann Pettee directing. A great many of the townspeople took part in the pageant, as nearly 300 volunteers lined up to work as pageant players, production teams, seamstresses, and general support staff. The play was based on the ancient Greek myth of Pandora's box, wherein a young woman named Pandora opens a mysterious box and accidentally unleashes anguish and woe upon the world, with the exception of hope. It could be said that the symbolism of the play reflected the hard times of the Depression and man's ultimate faith in a better future.

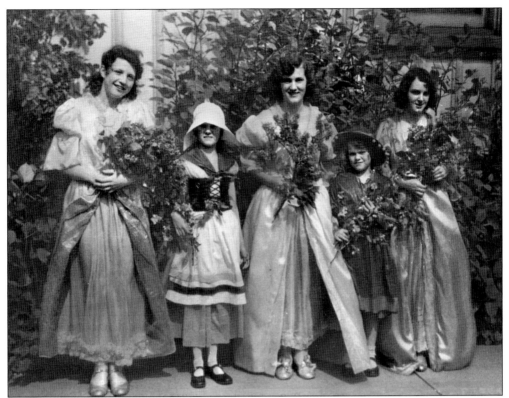

The second half of the pageant changed to a different century and was comprised of a medieval theme, which included a singing troubadour and a dance performed by wandering gypsies. Some of the members of the gypsy troupe (pictured here) line up to happily show off their costumes.

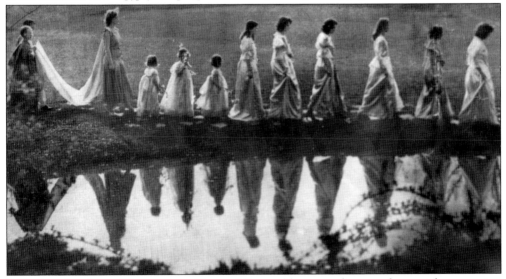

Following the close of the pageant, Queen Alice and her attendants made a stately procession to the hillside above the pond. From her lofty throne above the pond, the reigning queen held an open court, and the visiting crowd was invited to an audience with the queen and her royal courtiers.

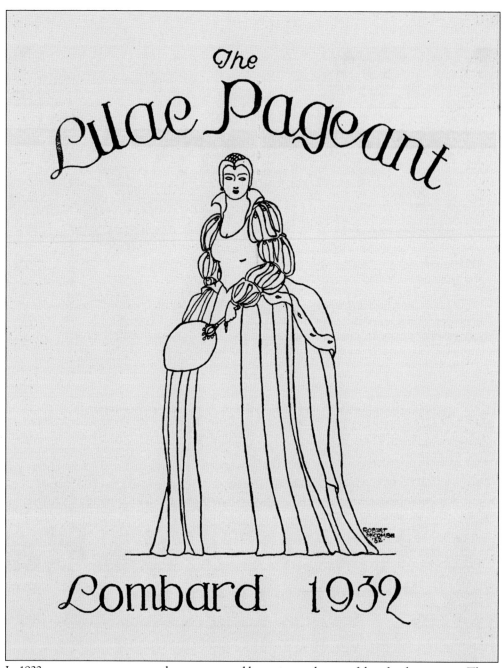

The Lilac Pageant

Lombard 1932

In 1932, controversy sprang up about a proposed last-minute change of date for the pageant. There was a state athletic meet scheduled for that same Saturday, preventing many cast members from attending, and the director wished to move the pageant to Sunday. The stricter church members in town disapproved of the idea of holding a festival on a Sunday, but there was worry that if the pageant were to be postponed for an entire week, the lilacs would be gone. The day was saved by a last minute decision to agree to hold the festivities in Lilacia Park on Sunday. As it turned out, the weather cooperated, and the change to Sunday was a wonderful opportunity for people to attend the fete. On the day of the pageant, the village was positively swamped by the influx.

The 1932 pageant was a medieval theme, with Clara Baumann Pettee repeating her role as director. The pageant opened with a fanfare of trumpets, and the climax came with the queen's crowning. Immediately following the coronation, a romantic comedy entitled *A Jewel in the Hand* was enacted, based on traditional plots used by the wandering players of the Italian Renaissance.

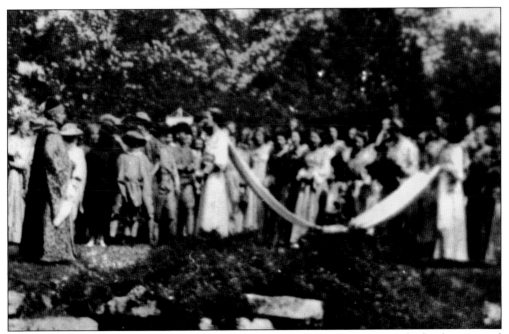

The highlight of the pageant occurred when 18-year-old Rebecca Howe, a Glenbard senior and the daughter of Charles E. Howe of West Maple Street, was crowned as the 1932 Lilac Queen. Her selection as queen came as a complete surprise to Rebecca, as she had not put her name in for application; a friend had submitted her photograph without her knowledge.

4th ANNUAL LILAC PAGEANT

LOMBARD, ILL., MAY, 1933

Heavy rains fell in early May 1933. Consternation was running high, as everyone wondered if the lilacs would bloom in time for the chosen date of May 13 and then fall victim to the downpour. With the threat of not being able to stage a pageant this year, the Lombard League Committee met continually to discuss the issue and to seek a possible solution to the problem. Finally, an announcement was published that the pageant would have to be postponed until May 20. The choice turned out to be a fortuitous one; although the temperature was a bit cool, the skies finally cleared, and the blossoms put forth their heady fragrance. Word of Lombard's beautiful Lilacia Park was growing in the land; the park registry for 1933 showed that visitors to the park had come from every state and a dozen foreign countries.

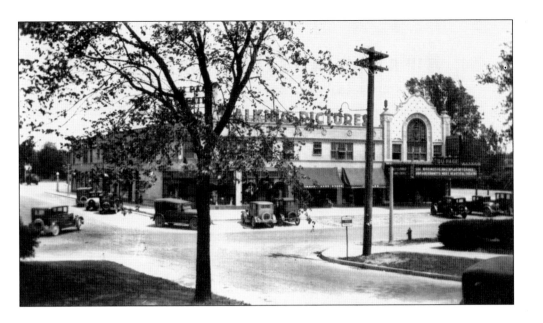

As the fame of the Lilac Festival had grown, the contest for Lombard's Lilac Queen became a celebration in its own right. A different venue was chosen; the selection of the queen would be announced at a colorful ceremony held at the DuPage Theater (shown here) where the townspeople could be in attendance. Each girl was to wear a pageant gown of her choosing and make a brief appearance on the stage. The judging committee's selection was announced to the audience of nearly 1,000 people who attended the ceremony at the DuPage Theater that evening.

The Lilac Queen chosen for 1933 was Mildred Fryer, who was selected from the 30 attractive young ladies who had submitted their entries. The theme for this year was "Choosing of the Queen for a Medieval Carnival," and Fryer was to play the part of a young village girl.

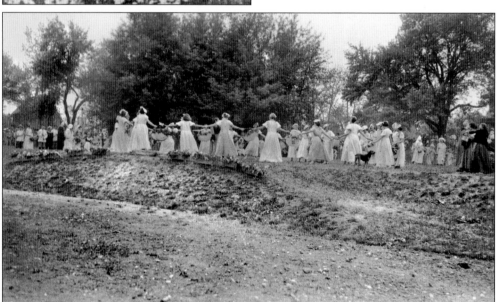

The year 1933 was a banner year for Lombard, having two notable Lombard residents writing and directing the pageant. The play this year was written by Katharine Reynolds and directed by Harriet Taylor. The pageant was moved from Lilacia Park and was staged in a lot directly across from the park, with the players cavorting on the high ground and the audience seated in a grassy depression alongside the natural stage.

Providing costumes for hundreds of cast players would normally be a daunting task: there were costumes for the townspeople, for the royal court, and, of course, for the queen herself. But a determined army of seamstresses worked diligently day and night to sew every costume and have them ready in time for the pageant. Shown here are just a couple of the original sketches of the dozens of costume designs.

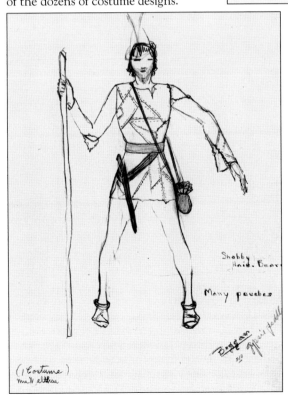

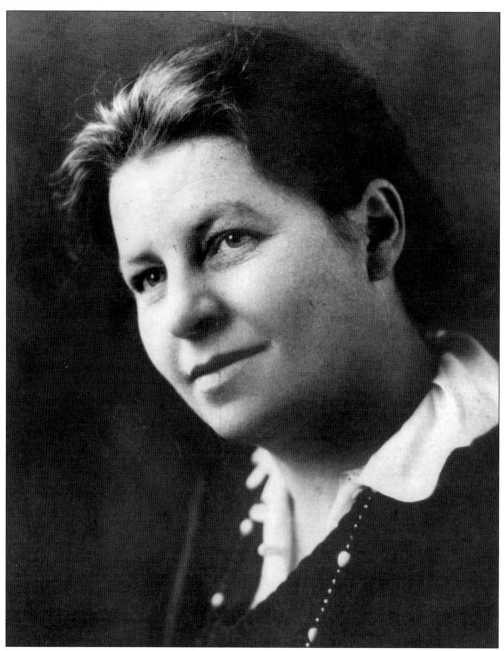

Katharine Reynolds was a renowned and highly respected member of the Lombard community. She was responsible for starting the town's first newspaper, the *Lombard Breeze*, publishing her first issue in 1912. Katharine became famous with the publication of her first novel, *Green Valley*, a nostalgic look back on her life in Lombard, which hit the best-seller list. One of the chapters in her novel was actually entitled "Lilac Time;" it is ironic that perhaps this reference was a foretelling of the festivities that would occur years in the future. Following her success, she wrote *Willow Creek*, which also became a best seller. In 1933, Reynolds was enlisted to write a play for the lilac pageant, ensuring it would be a roaring success. The script from the pageant still exists and is a treasured historic item.

5th ANNUAL LILAC PAGEANT

MEDIN

LOMBARD, ILL., MAY, 1934

Charles Medin had designed several of the pageants' program covers as well as the artistic posters displayed around town. The program cover for 1934 depicted a pastoral scene showcasing the plot of the pageant play. The story line was of a simple peasant girl of "Merrie Olde England" who comes to join the festivities in the village and then, to her great surprise, is chosen to be a prince's consort from among all the other pretty maids of the village. It was planned to have the winner of the Lilac Queen contest fill this role in the play, with her coronation following at the end.

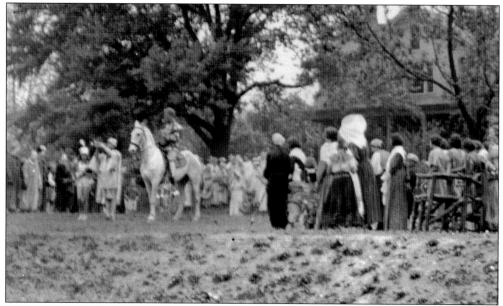

With Harriet Taylor not being available to repeat the position of director from the previous year, Katharine Reynolds agreed to take on the additional responsibility of directing the production. The previous year's play was such a success that public demand called for an encore. Reynolds reprised her original script, with a few minor changes. More cast members were added, as well as a Lilac Prince. Allan Hubbard, pictured at left, was chosen as the prince. The pageant was extended to play both on Saturday and Sunday to accommodate the number of visitors pouring in.

Ruth Melka had the honor of becoming the Lilac Queen in 1934, being chosen from an amazing number of 212 applicants. A story was told that at the close of the pageant play, the queen was to ride in on horseback, but the horse reacted nervously to the noise of the trains as they passed by, and the poor queen turned ghostly white with fright as she held on for dear life.

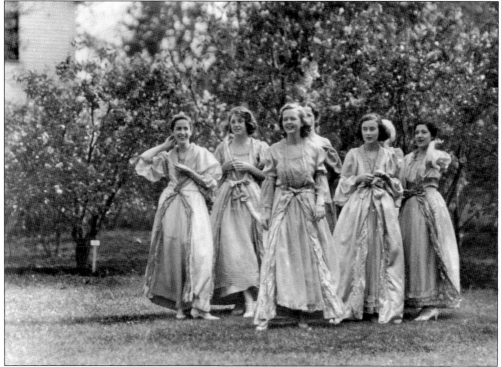

This year another novel feature was added to the original pageant. As the festivities came to a close, members of the pageant cast began a grand march, winding their way around the park. The grand march culminated in a street dance, much to the delight of the visiting crowd. The young ladies of the pageant cast stop for a moment to pose for the photographers.

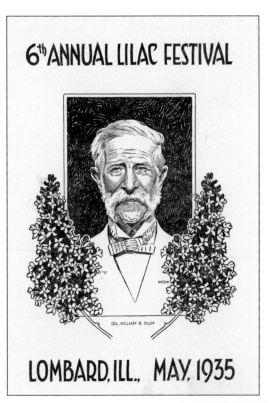

6th ANNUAL LILAC FESTIVAL

COL. WILLIAM R. PLUM

LOMBARD, ILL., MAY, 1935

The theme for 1935 told the story of Colonel Plum and his wonderful contribution to the Village of Lombard. A new innovation this year, a narrative written about Colonel Plum was read to the crowd over a loudspeaker. Songs and dances, representing foreign lands and cultures, were performed to represent William and Helen Plum's travels to distant countries in order to add to his already extensive lilac collection.

Out of 45 entries, Sylvia Asher was the lucky girl chosen to be Lilac Queen in 1935 by a unanimous decision of the judging committee at the public ceremony held at DuPage Theater. Asher was a natural choice, having had previous experience in the previous year's festival. She was a runner-up, served as a court attendant, and now was a Lilac Queen in her own right.

The queen's selection returned to strictly a popularity contest for 1936. Ballot boxes went up again at the local merchants for everyone to have the chance to vote for their choice. The naming of the chosen queen was scheduled to be announced at a Grand Ball on May 16. A total of 60 young ladies had been nominated, and Jean Curtis won the popularity contest as the queen. When learning of her selection as queen, she stated that she was surprised and overwhelmed by the news. In the photograph below, Queen Jean approaches the stage to receive her crown as Lombard's Lilac Queen.

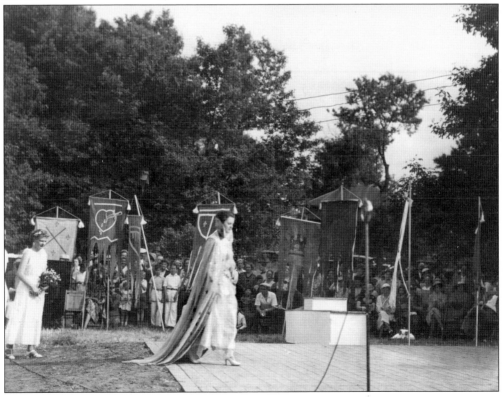

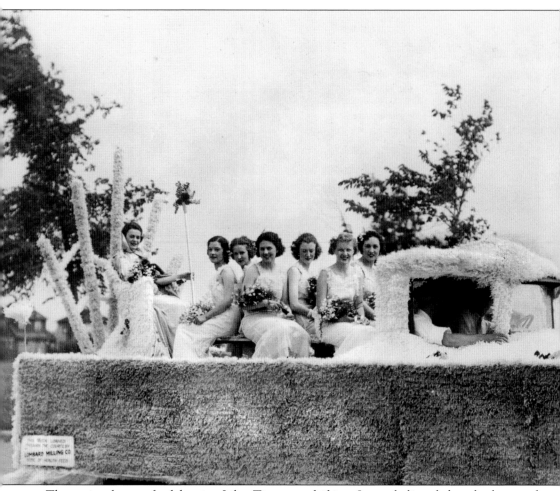

The entire theme of celebrating Lilac Time was shifting. It was believed that the long and complicated pageant plays of the previous years should give way to a parade through the business section of the town. Businesses, organizations, and even individuals were encouraged to enter decorated floats for liberal cash awards. In addition, a series of afternoons and evenings were planned for musicals and dancing to be individually sponsored by various community groups. The festivities would close with the parade on Sunday, May 24. Seen here, the Lilac Queen and her court ride through the parade on a float provided by the Lombard Lilac League. In this way, the celebration of "Lilac Time" would be held throughout the entire village and not centered only in Lilacia Park. However, this rang the death knell for the pageants, and the year 1936 would mark the last time that a Lilac Queen was chosen for a long time.

Four

1937 TO 1946:
CELEBRATIONS ON HOLD

As the hardships of the Depression wore on, followed by the outbreak of World War II, there were no longer any of the elaborate pageants or rousing parades. There was no longer a Lilac Queen. But in the park, the lilacs still bloomed in May, the music played on, and the crowds still came to see the peak of the bloom.

As a substitute, the park installed a Hammond organ, and there were nightly concerts for a full week in May. Later the organ was replaced by amplified music continually playing throughout the park for visitors to enjoy. During the peak of the bloom, record crowds still came to Lilacia Park, and so many automobiles were backed up on Roosevelt Road that people were turned away at Main Street.

DuPage County celebrated its centennial in 1939, and Lombard's Lilac Festival featured celebrations and a parade to mark the year. The business section on St. Charles Road was decorated in observance of the celebration.

During World War II, wartime restrictions greatly reduced the number of out-of-town visitors, but neighboring communities were still well represented. As the war waged on, many of the visitors included servicemen enjoying a brief respite from the harsh realities of combat. All military personnel were admitted free to the park if they showed their identity pass. A highlight of the 1942 lilac festival was a USO Community Street Dance held in honor of servicemen on May 9. Invitations were sent out to all staff members and patients of Hines Hospital and the new Vaughn Army Hospital in Maywood to visit the park as guests. Busloads of soldiers and sailors arrived. Park Avenue, the east boundary of Lilacia Park, was blocked off to provide room for dancing, the musicians, and tables of refreshments, all donated by grateful Lombard citizens.

When the war ended, the visitor count climbed remarkably. The 1946 attendance broke all previous records. The intersection of Maple and Main Streets resembled State and Madison Streets in Chicago during the weeks before Christmas. Folks were formed up into a line with four abreast to await admission to the park. A veteran Lombard police officer who was directing the crowds remarked, "I never saw a day like it in my life." And yes, the crowds still came.

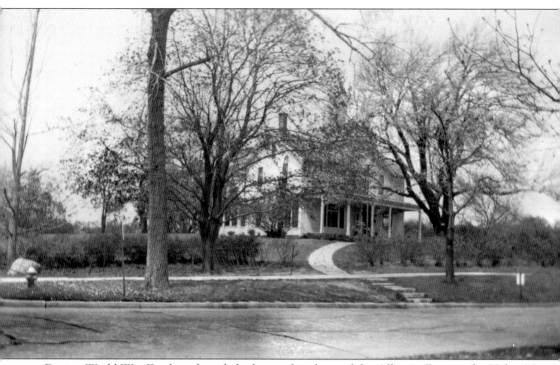

During World War II, when the tide had turned in favor of the Allies in Europe, the Helen M. Plum Memorial Library in the former William and Helen Plum house on Park Avenue looked bleak on this day in 1944. The sidewalk was five steps above the street, and the library's sidewalk curved invitingly up to the impressive home.

Local newspapers laid out on a table invite the library patron into a reading room, with posters about coming meetings on the post to the right. While the house architecture remains as the Plum family left it, the lighting is new, with utilitarian globe designs illuminating this section of the library.

A rare look at the entry foyer of the Helen M. Plum Memorial Library can be seen here. On the left is a steam heat radiator next to the austere framed door, itself framed by the same style door frame in the foreground. The door leads to the reading room with a clock mounted high on a bookcase. A staircase with well-turned finials of differing sizes to accommodate the stair itself provides support for the patron.

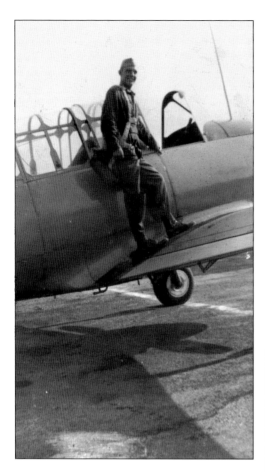

Most of the young men volunteered or were drafted into service in World War II, and some of the young women from Lombard volunteered for the women's service units like the WACs, WAFs, and SPARs. Some of the servicemen sent photographs home from overseas or training bases, such as Howard Cosyns on the wing of his army trainer airplane (at left) and Raymond Kammer seen below at the 878 Airborne Engineers, Company B, Corps of Engineers.

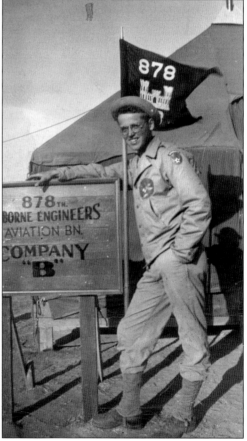

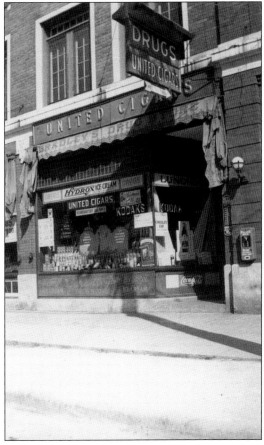

Bradley's Drug Store, owned by James Bradley, was located just north of St. Charles Road on Main Street. It was a favorite stop for the young people of the village. During the war years, Bradley's played a large part in the lives of the residents since it served as an unofficial gathering place for folks to send and receive letters from servicemen. Many of the letters sent to Lombard were addressed to "Mr. Bradley at the drugstore" and were shared on a bulletin board for anyone interested. The exterior had the United Cigars sign above the window, and inside there were four or more tables for a quick soda or snack. Dick Tracy and Little Orphan Annie comic books were available on a stand for 10¢.

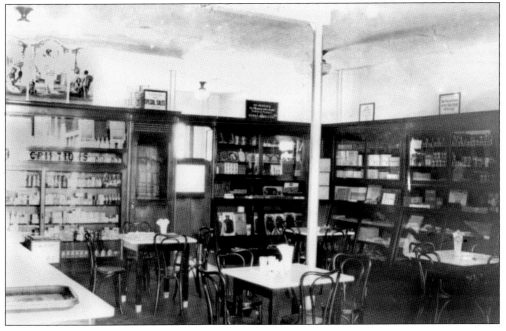

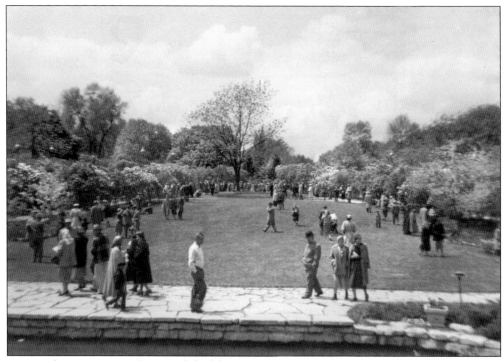

Late in the war years, Lilacia Park had been cleaned up, and there was no longer any rustic fencing by the fishpond. A new decorative flowerpot, in the foreground, was at the water's edge, and most of the visitors were drawn to the western end of the central field at the park's center for the best display. The lilacs are the primary attraction, and the tulips are noticeably absent, setting the date to around 1944.

Just before the 1945 Lilac Time, the area above the limestone ledge was cleared of bushes and plantings to provide a review area. The speakers would look out over the green assembly area as seen here. This openness became the preferred design and is still in use today.

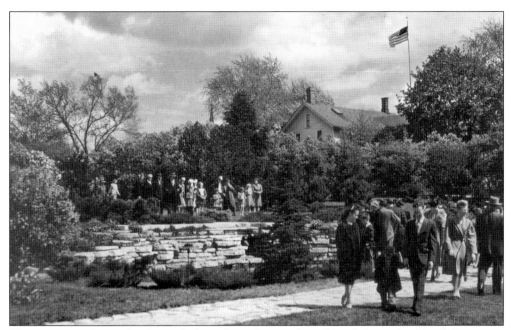

The new open design for the park shows how the people gathered above the waterfall are now far more visible than in the Jensen design. It is 1945, and the limestone path is still present in the foreground, while high above the park, the new flagpole holds Old Glory well above the library roof.

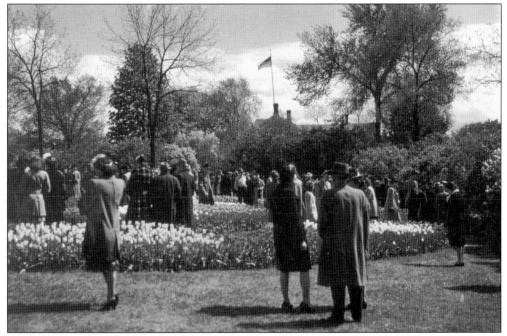

The library appears to have a new extension on the right to house more books. This view is from well back in the western section, and it is a chilly spring afternoon with a south wind blowing the flag briskly. The tulips are in full bloom, and some of the lilacs have blossomed. The stark tree limbs and branches suggest that this is an early April view of the park.

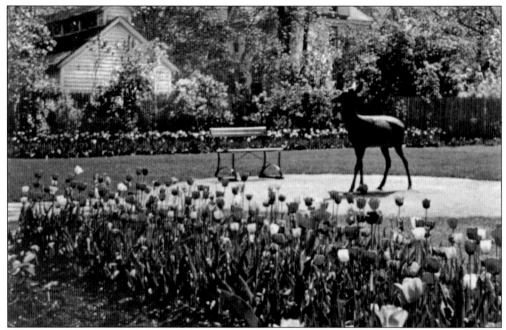

The park originally placed Rastus in the center of a walking path surrounded by tulip beds. After the war years, the deer was placed on a solid platform and moved to the west side of the park. Rastus lost his antlers in the 1970s when someone wrenched them from his head one dark and windy night.

The unsung heroes, park district workers had weeks of specialized labor to complete in the fall as they planted the tulip bulbs and provided care for the tulip beds. The lilac bushes also needed their share of pruning and, in some cases, replanting.

Five

1947 TO 1980:
THE BUDS BLOSSOM AGAIN

The war was over, and the servicemen and women were coming home. Joy returned to the land, hope had survived, and hearts could love again. In 1947, as the privations of the Depression and the austerity of the war years lessened, the Lombard Camera Club campaigned to reactivate the selection of a Lilac Queen and her court of Lilac Princesses, although without the pageants. The premise was to "supply photographers with lovely material to enhance the famed beauty of Lilacia's floral display." It had been more than a decade since there was a Lilac Queen, and the time was ripe for the tradition of a queen and her court to return.

A contest to select a Lilac Queen and her court was to be sponsored by the camera club, but it was not going to be a simple popularity contest anymore. In April, an announcement was published asking all eligible young women between the ages of 16 and 22 to send in a photograph of themselves. The most photogenic girls would be selected by a panel of impartial judges, none of whom would be residents of Lombard; these judges would rate the girls on personal grace, charm, poise, and a pleasing voice. The young women of the town were to submit an application, which the judges would review and then interview each of the contestants. The girls were assigned numbers in place of their names. The selections were made on a point system, and even the judges did not know the winners until the points were totaled.

Five Lilac Princesses were chosen as finalists, and these young ladies were to serve as models in formal attire throughout the entire duration of Lilac Time in the gardens, culminating with the coronation of the Lilac Queen. Following the previous hard years, gone were the austere styles of hand-me-downs and makeovers, and out came the ruffles, lace, and yards and yards of crinolines. The young ladies of the town were eager to embrace the newer, more fashionable ball gowns.

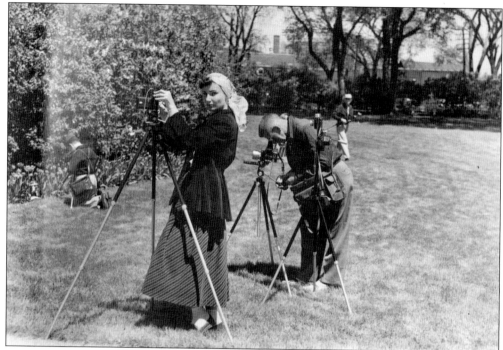

In the early photograph shown above, unidentified members of the Lombard Camera Club are setting up their equipment for photographing the queen and her court in Lilacia Park. The Lombard Camera Club played an important role in the reinstitution of a Lilac Queen to preside over the festivities during Lilac Time in Lombard. It was thankfully due to their efforts that the queen and her court came back into being. Pictured below, a member of the camera club and the Lilac Court are preparing for a photographic session in the park. The styles of the girls' dresses in the photograph indicate that it is probably in the mid-1950s.

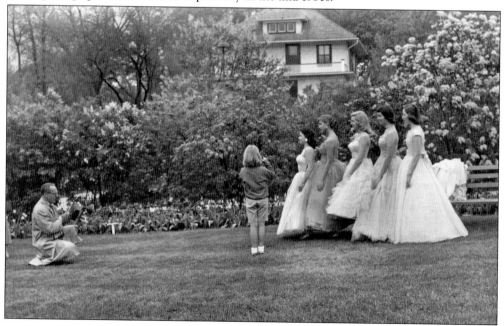

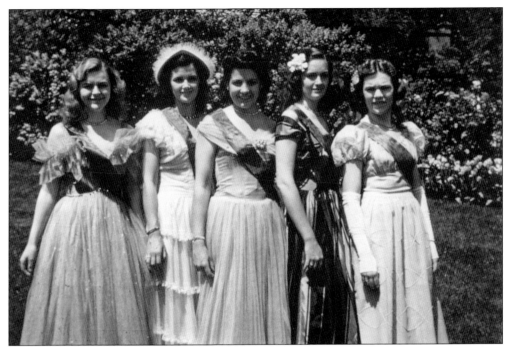

The identity of the chosen queen was kept a secret until the coronation ceremony, when Betty Bean was selected as the first queen in more than 10 years. Posing for the photographers is the Lilac Court for 1947; the young lady in the hat is Queen Betty Bean, while standing in no particular order are the Lilac Princesses: Omond Childs, Helen Murphy, Charlotte Reis, and Lora Standish.

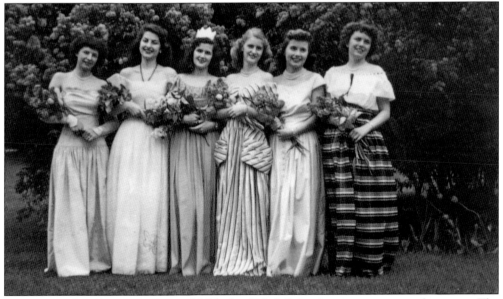

In 1948, Marilyn Shearer, a 17-year-old Glenbard High School senior, was crowned as queen. The Lilac Court is shown here standing with last year's queen. From left to right are Jeanne Krause, Rosemary Kett, 1947 queen Betty Bean, Queen Marilyn Shearer, Pat Dearinger, and Patty Moloney. As done the previous year, the selection was kept a secret until the coronation.

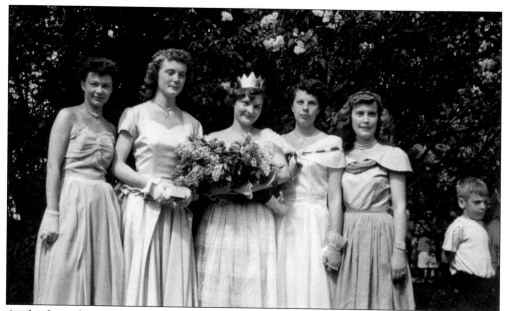

At the festival in 1949, sixteen-year-old Patricia Fuller became the youngest queen ever to be crowned. The queen's head was adorned with a hand-wrought crown fashioned from tin. Queen Patricia Fuller and the Lilac Princesses—Pat Byrne, Jean Freund, Norma Jean Wendt, and Donna Whiteley (in no particular order)—made themselves available to the photographers.

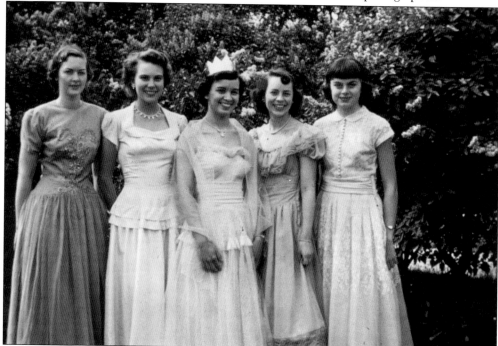

In 1950, the crown was placed on the head of Queen Joanne Hale by honored guest Harry Campbell, WBBM radio personality and a Lombard resident. The queen's court poses for a photograph in the park; Queen Joanne Hale is surrounded by her court of Lilac Princesses, Ruth Auberg, Donna Jean Durham, Nancy Hoag, and Patricia Murphy (in no particular order).

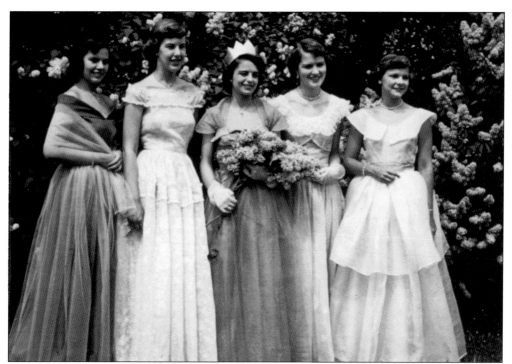

Patricia Sheridan received the queen's crown in 1951, and afterwards the Lilac Court posed for the photographers. Standing are Queen Patricia Sheridan (center) and the Lilac Princesses, Shirley Dammann, Margie Johnson, Lynn Koykar, and Barbara Spence (in no particular order). The Lilac Festival received television publicity that year when John Nash Ott Jr. described the event on his television show the day after attending the festival

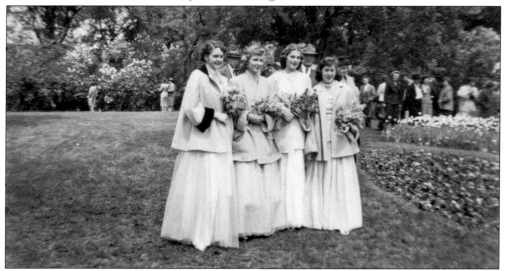

It was a cool, rainy day when Joan Archbold was crowned queen in 1952, and the ceremonies came to a quick close as rain poured down on participants and spectators. The Lilac Court huddled in their jackets as photographs were taken. Standing, from left to right, are Geraldine Miller, Carolyn Kolze, Marlene Lindsay, and Queen Joan Archbold. Absent from the picture is Lilac Princess Nancy Meyers.

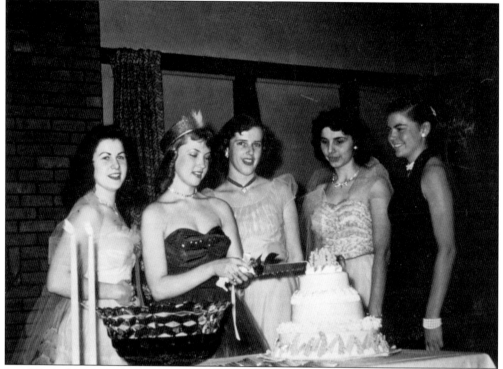

Joye Wardecker, a Glenbard senior, was named the Lilac Queen in 1953 and was crowned with the hand-wrought tin crown. Queen Joye cuts into her cake as the Lilac Princesses look on. Standing to the left of the Lilac Queen is Inga Horst, and to the right are Lois Lane, Raenata Lehman, and Patricia Wolff (in no particular order).

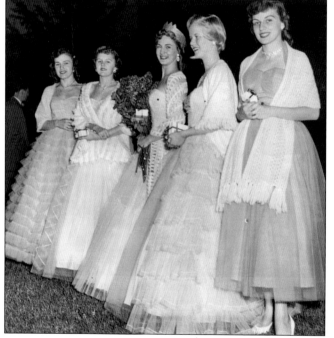

Glenbard junior Jackie Ramey was selected as the reigning Lilac Queen for 1954. At the gala reception dance later that evening, the queen and court posed prettily for the photographers. Pictured from left to right are Lilac Princesses Eileen Nicholson, Judith Tomamichel, Queen Jackie Ramey, Naomi Jorgensen, and Connie Bednarz.

Jim Conway, popular star of radio and television, placed the tin crown on the head of Carol Brown in 1955. Then the Lilac Queen and Lilac Princesses held court in the park afterward for the benefit of the photographers. Pictured from left to right are Queen Carol Brown, Sandy Larson, Arliss Paulson, Lois Albertson, and Nancy Widman.

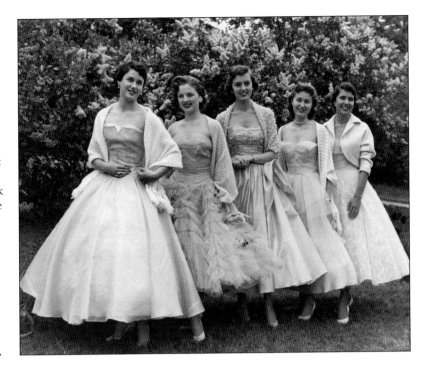

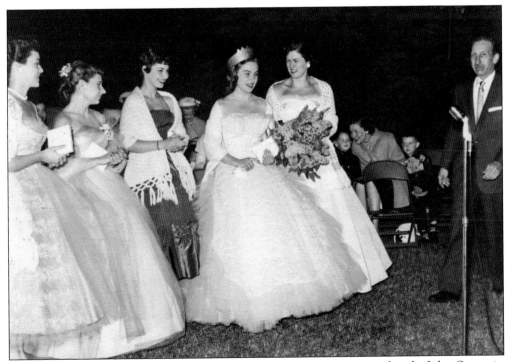

In spite of cold weather, hearts were warm as Laura Kaiser was announced as the Lilac Queen in 1956. The moment is captured by the photographer as the queen and court, braving the chilly night air, are introduced to the crowd. Pictured from left to right are Pat Weber, Arlene Piepers, Judi Moore, Queen Laura Kaiser, and Jean Bauman.

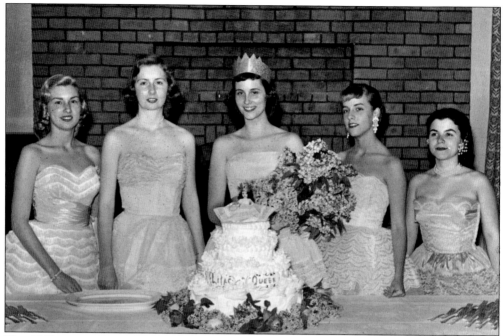

The 1957 queen was Karen Ridgway, who was crowned by Norman Klapp, president of the Lombard Park District Board. Due to bad weather, the crowning was held in the auditorium of the Lombard Junior High School. Posing here before the traditional cake-cutting ceremony are Queen Karen Ridgway (center) and Lilac Princesses Jane Ferguson, Judy Maisel, Shirley Matlock, and Betty Wingard (in no particular order).

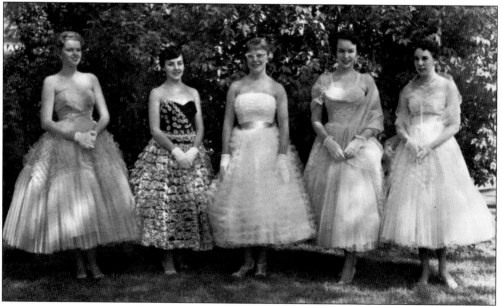

It was a magical night at Lilacia Park as twilight formed the background when Deanna Domler was crowned the Lilac Queen in 1958. On one of the sunny days before the coronation, the Lilac Court poses for a photograph. From left to right are Phyliss Francis, Barbara Snider, Barbara Staedke, Queen Deanna Domler, and Gail Hazekamp.

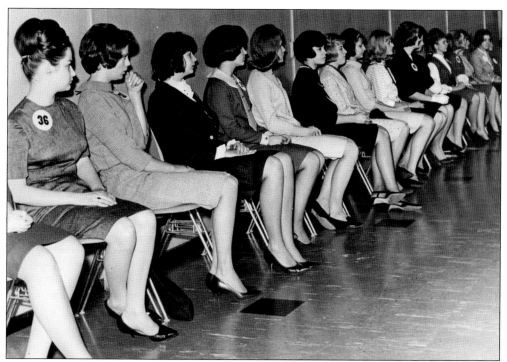

In 1959, several community organizations joined with the Lombard Camera Club to sponsor the pageant contest, including the Lombard Service League, the Lombard Junior Woman's Club, and the Lombard Jaycees. The bar was now raised: besides personal appearance and a pleasing personality, emphasis was now being placed on scholastic achievement and community activities. As represented in the photographs above and below, aspiring contestants nervously await their turn to be interviewed by the judging committee. The advice always given is to "just be yourself" and "smile," but there is not one girl in the crowd that does not feel just a little bit anxious when facing the judges.

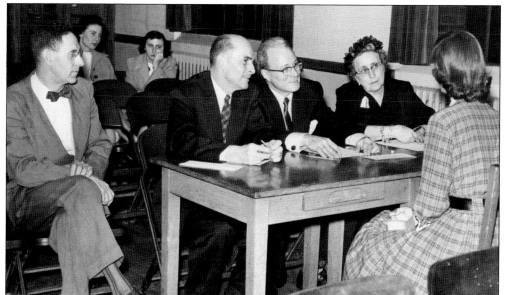

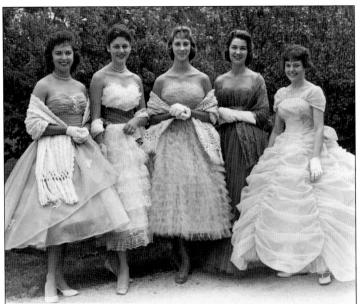

Beverly Carlson, a York High School senior, was chosen as the 1959 Lilac Queen and was presented with a new crown. Weary of seeing the homemade tin crown, the Lombard Service League began the presentation of a sparkling rhinestone tiara more befitting to a queen's station. Standing from left to right is the 1959 Lilac Court: Queen Beverly Carlson, Jody Cremerius, Carol Sue Hesselgrave, Mary Novak, and Kathy Stanton.

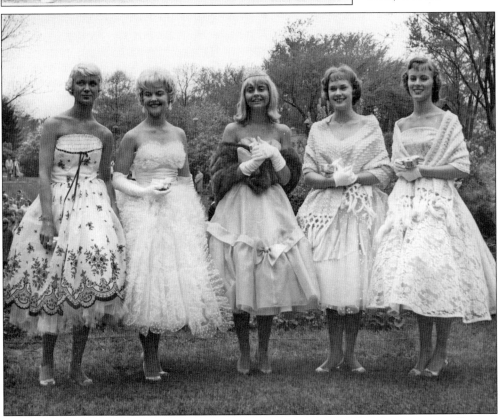

In 1960, Glenbard senior Michelle Little was picked to reign as the Lilac Queen at a cotillion on April 29, but she was not crowned until May 7, just before the parade was to commence. Posing in the park on a rather cool day are, from left to right, Judy Smith, Beverly Kushman, Queen Michelle Little, Delores Heide, and Julie Ferry.

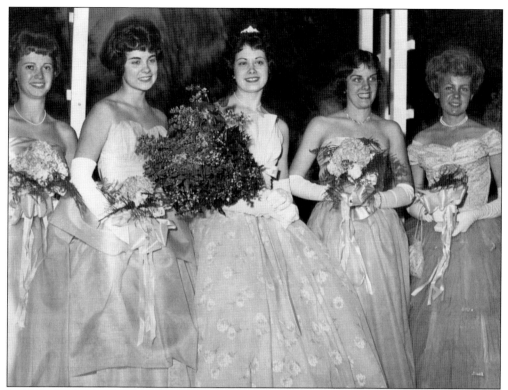

In 1961, the final judging was held during the Lilac Ball at the Lombard Community Building. Queen Betty Jean Barnet, a Glenbard East senior, was crowned at the climax of the celebration by television personality Lee Philips. Posing for the cameras afterwards are, from left to right, Joyce Gardner, Rebecca Fossdal, Queen Betty Jean Barnet, Suzanne Long, and Patricia Donath.

Connie Capitanelli was selected as the Lilac Queen for 1962. Among the honored guests at the festivities was Ned Locke, the well-known ringmaster of Bozo's Circus, who served as Queen Connie's escort for the coronation. Happily posing for their youthful admirers in the park are, from left to right, Sharon Boyer, Carol Jordan, Queen Connie Capitanelli, Lou Chambers, and Judith Ann Fleege.

In 1963, the queen's crown was placed upon the head of LaVonne Tanswell by the previous year's queen, Connie Capitanelli. Later that evening, Queen LaVonne entered through a gateway arch to open the Queen's Ball at Lombard Community House. Without an available photograph, Lilac Princesses Sherrill Beckwith, Nancy Carlson, Karen Kluender, and Sandy Schroeder are not seen here.

The chosen queen for 1964 was Carol Lynn Burke, a senior at St. Francis High School. As 1964 was marked as the silver anniversary, many of the past queens were in attendance. The ceremony was especially poignant because Queen Carol was crowned by Adeline Fleege Gerzan, Lombard's first Lilac Queen in 1930. Standing from left to right is the Lilac Court: Susan Larson, Janice Hildenbrand, Queen Carol Lynn Burke, Margaret Thompson, and Susan Ness.

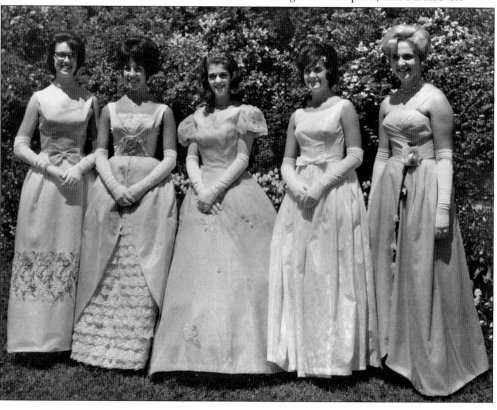

For the first time, six princesses were selected, as there was a tie for fifth place. Out of these finalists, Linda Chambers, a senior at Willowbrook High School, was chosen as the 1965 Lilac Queen. Posing for the photographer at the Lilac Ball, hosted by the Lombard Area Chamber of Commerce and Industry, are, from left to right, Sue Crosby, Betty Lynn Bell, Queen Linda Chambers, Nancy Moon, Helene Wlochall, and Eileen Sajovic.

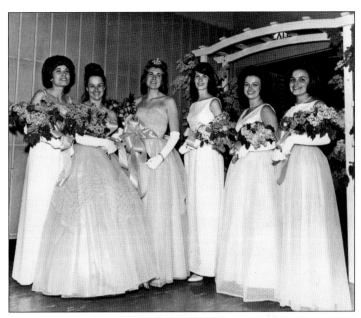

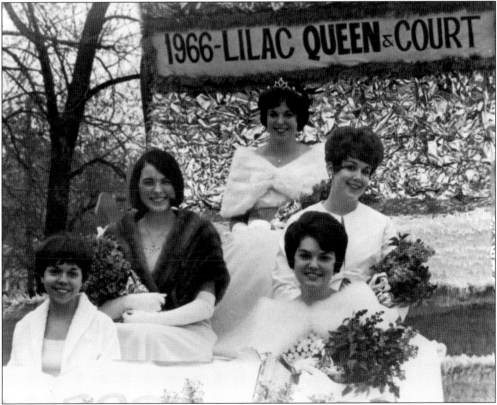

Ringmaster Ned Locke returned to Lombard in 1966 to crown Bonnie Boal as the new Lilac Queen. The Lilac Queen and Lilac Princesses were photographed as they took part in the annual Lilac Parade. Pictured from left to right are (first row) Glenda Klein and Jeanne Eme; (second row) Joanne Wille and Lynn Noonan; (third row) Queen Bonnie Boal seated on her throne.

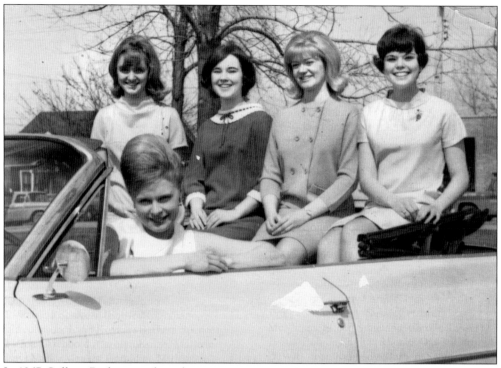

In 1967, Colleen Burke was selected as queen. An unusual coincidence, her older sister Carol had reigned as queen three years previously. The Lilac Court strikes a pose in an open convertible. Pictured from left to right are Suzanne Beavers, Linda Larson, Karen Anderson, and Queen Colleen Burke, with Gerie Holsinger sitting at the wheel. Because of poor weather, the coronation was held at the Green Valley School.

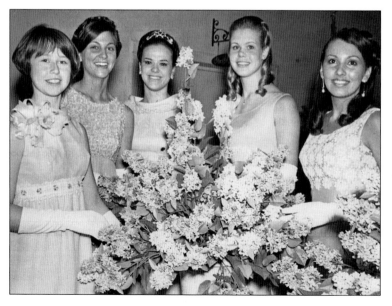

Sandie Wlochall, a 17-year-old Willowbrook senior, became the 1968 queen of the Lilac Festival and was presented with the queen's crown. Standing from left to right, Judy Larm, Gayle Cunningham, Queen Sandie Wlochall, Sandy Thompson, and Mary Bicicchi put on bright smiles for the photographer as they pose amid the beautiful lilac blooms.

In 1969, Lombard was celebrating its 100th anniversary as Glenbard East senior Susan High was crowned Lilac Queen that year. Standing in Lilacia Park on a beautiful sunny day, the Lilac Court poses for the photographers. From left to right are Betty McMillan, Eileen Smietana, Carolle Tanzer, Queen Susan High, and Susan Gerhardt.

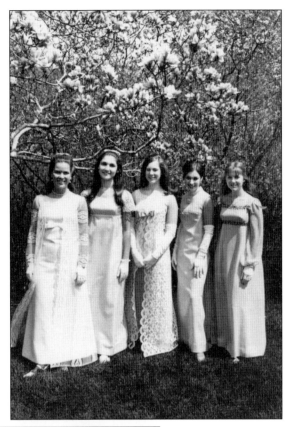

In 1970, seventeen-year-old Bonnie Shultz, a Glenbard East senior, became Lilac Queen. For the first time, the Lombard Service League presented a tiara to each of the four Lilac Princesses, in addition to the queen's crown, for them to keep as a remembrance of their reign. Standing on stage, from left to right, are Rhonda Davis, Carol DeWitt, Joan Kennedy, Barbara Schatz, Queen Bonnie Shultz, and 1968 queen Sandie Wlochall.

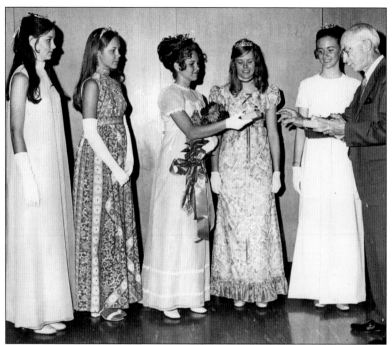

In 1971, Jean Marie Amundsen was crowned queen amid the "Wonderland in Lilac Time." The Lilac Queen and Lilac Princesses are shown here being presented with gifts from Lombard park district commissioner Thomas Boa. Standing (in no particular order) are Queen Jean Marie Amundsen, Elaine Bellock, Patricia DeWitt, Laurie Kucera, and Anita Nowak.

In 1972, nineteen-year-old Glenbard East graduate Doranne Moulder was chosen as Lilac Queen. Doranne won the honor on her second try; she had applied two years earlier but had not made it to the finals at that time. Standing from left to right are Jaynee Lee Buettner, Ruth Maas, Queen Doranne Moulder, Peggy Kusak, and Sherry Steiger.

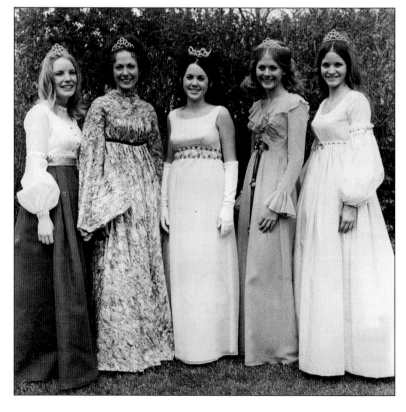

The Lilac Queen of 1973 was Barbara Wetzel, a graduate of Glenbard East High School. Pictured from left to right are (seated) Lilac Princesses Tina Geroulis and Carol Heavener; (standing) Lilac Princesses Gail Ann Ferrier and Judy Reuhl, and Queen Barbara Wetzel. For the coronation of the queen, the Lombard Park Players brought back a little of the old pageantry by reenacting a short medieval play.

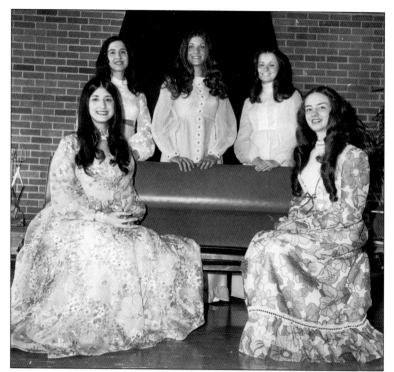

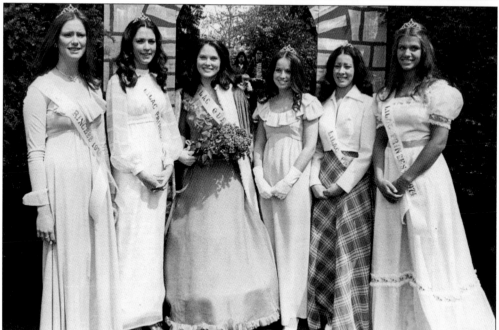

In 1974, the selected queen was 17-year-old Donna Lee DeForest, a freshman at Elmhurst College. Again this year, the Lombard Park Players performed and reprised their roles of the previous year. The queen and court pose in front of a medieval backdrop. Pictured from left to right are Carrie Kravchuk, Suzanne Piche, Queen Donna Lee DeForest, 1973 queen Barbara Wetzel, Penny Chippas, and Donna Johnson.

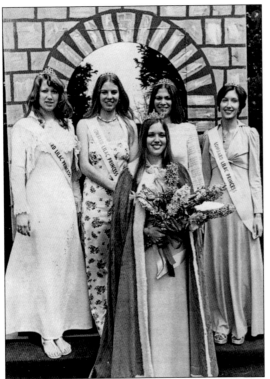

In 1975, a proclamation was read announcing Debbie Baumann, a Glenbard East senior, as the winner. Beginning that year, the queen's crown was passed on to succeeding Lilac Queens, and tiaras were presented to all five princesses in a formal ceremony in the weeks before the coronation. The Lilac Princesses, standing behind Queen Debbie Baumann, are, from left to right, Betty Rider, Janet Grass, Janice Swanson, and Lynn Cantura.

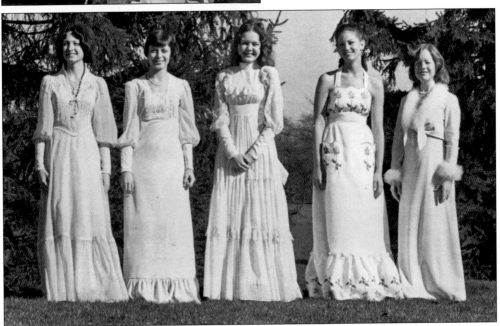

In 1976, the honor of Lilac Queen went to Jenneine Rowley, a student at George Williams College. As 1976 was the country's bicentennial, the theme for the coronation was a replica of Independence Hall, from which the Lilac Queen and each of the Lilac Princesses emerged on the arm of a Colonial page. Standing from left to right are Ann Cadagin, Teresa Owens, Queen Jenneine Rowley, Laurel Kleefisch, and Loretta Rakebrand.

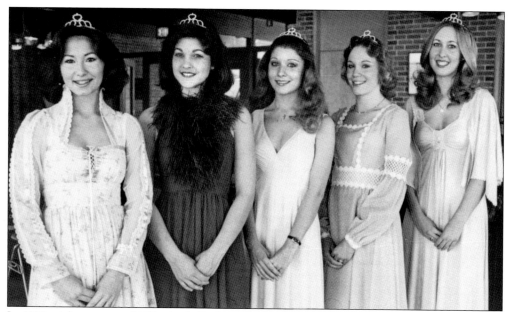

In 1977, eighteen-year-old Elizabeth Pool, a Glenbard East senior, was selected as Lilac Queen. With the theme of "50 Years of Talking Pictures" as their cue, the Lombard Park Players portrayed famous Hollywood stars from the past. The members of the Lilac Court, seen here from left to right, are Cindy Scavone, Lou Ann Santelli, Queen Elizabeth Pool, Carrie Dexter, and Melody Chrisman.

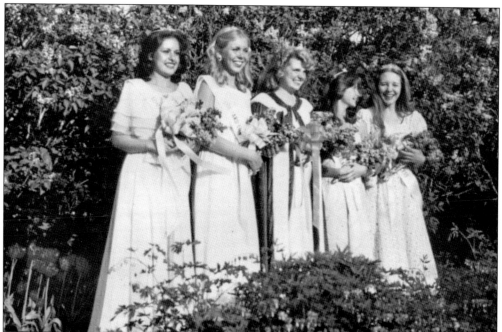

Kathy Happel, an 18-year-old senior at Montini High School, was chosen as queen for 1978. The Lilac Court poses for the photographer. Pictured from left to right are Pauline Ureta, Sharon Hattendorf, Queen Kathy Happel, Nora Ferris, and Mary Rowley. Queen Kathy stated that her mother and grandmother were also participants years earlier, and she was following a family tradition.

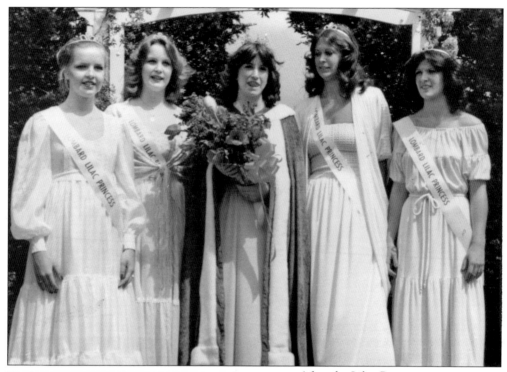

After the Lilac Princesses were introduced and the queen's selection was made, 17-year-old Gaye Rivers emerged the winner as the 1979 Lilac Queen. Standing under an arbor of flowers, the members of the Lilac Court are Queen Gaye Rivers, Susan Bethke, Paula Blackwell, Linda Moorhead, and Heidi Nordstrom (in no particular order).

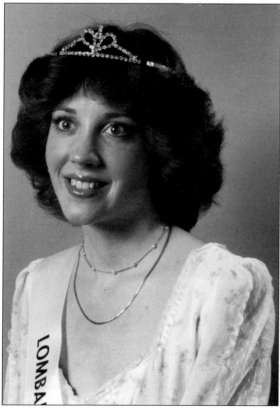

The year 1980 was a watershed year; 50 years had passed since the first Lilac Queen was crowned. Kathi Lynch, the new queen, was a worthy successor. A freshman at the College of DuPage, she also found time to perform voluntary teaching duties at the Montessori preschool. A photograph of the Lilac Princesses—Laura Doyle, Karen Erland, Selina Moriarty, and Kitty Thomas—was not available.

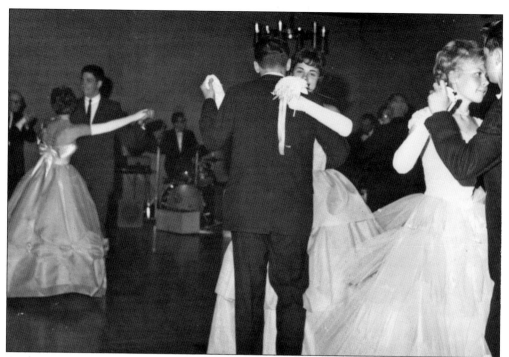

As shown by the photographs on this page, all are enjoying themselves as they dance the night away to the strains of lovely music at the Lilac Ball. It was through the auspices of the Lombard Area Chamber of Commerce and Industry that the institution of the Lilac Ball began in 1959, and the chamber has continued hosting the ball nonstop through the years. This traditional event celebrated its 50th year in 2009. The above photograph shows the Lilac Court opening the ball, with all the guests joining in below. By the styles of dress, the scenes shown here most probably date to the mid-1960s.

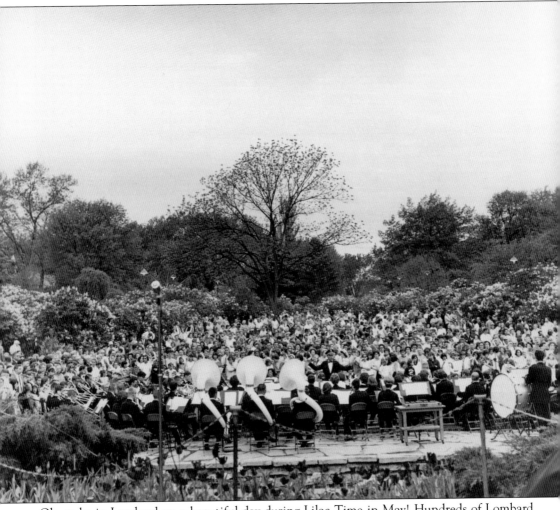

Oh, to be in Lombard on a beautiful day during Lilac Time in May! Hundreds of Lombard residents and out-of-town visitors turned out for the coronation ceremony in Lilacia Park. This photograph was possibly taken in early to mid-1960s. Looking out from the vantage point of the grassy stage above the pond, the photographer captures the visage and scope of the crowd. What better way to spend the day than to sit among the lilacs at the peak of their bloom, listening to familiar tunes provided by the Glenbard East High School Band, inhaling the sweet fragrance of the lilacs, and waiting for the finale. Then it comes; the drums roll, the Lilac Princesses are introduced once again to the crowd, and the announcement is made of the selected winner. And now a new Lilac Queen will reign over the festivities for another year.

Six

THE LILAC PARADES:
SPECTACULAR DAYS

Parades must seem like fairyland events to the very young; a sudden eruption of bands, floats, motorcycles, kids and wagons, and fire trucks that pass by for mere moments and then after an hour or so fade away up the street. There is a certain order to things: fire trucks come first with sirens wailing, then the lead band appears, followed by the first float. By the end, the last float arrives with the princesses and reigning queen, and the final band plays with horns blowing, drums drumming, and perhaps a triangle with its tiny silvery notes drifting in and out of the cacophony.

In 1936, the pageants were replaced with a parade, the first and last of the 1930s. One of the floats in that parade was entered as "Future Lilac Queens," and it was carrying a dozen or so young girls. The float was popular, and it won first prize in the civic group category. Sadly, there were no Lilac Queen contests held during the next 10 years, and no parades for 20 years.

The Depression and the war years eliminated the parades until 1957, ten years after the reinstitution of the Lilac Queen contest in 1947. The Lombard Area Chamber of Commerce and Industry proposed having a giant parade to herald the opening of Lilacia Park for the Lilac Festival for that year. There were to be four bands and any number of individual entries in the form of floats or characters in costume by some 25 different organizations. The parade was a success, and in 1959, the Lombard Parade Committee was organized to make the parade an annual event with each parade following a common theme for that year.

The parade has traditionally been led off in alternate years by the Lombard Junior High School Band and by the Glenbard East High School Band, with the designated band stepping off right behind the wailing sirens of the fire trucks from Lombard and the surrounding communities.

A motorized street sweeper was assigned to follow the equestrian units to clean the street and to spray pleasant lilac scented water as it passed. Unforgettable was the year that the sweeper's driver got more pleasure from his chore than expected. The machine spun around in random circles and then swooped down on piles of equestrian waste. It was the funniest unit in the parade, but the committee, which requires careful removal to prevent any hazard to the parade watchers' safety, was not amused.

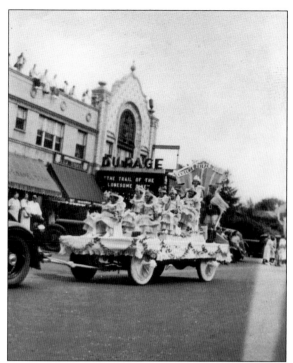

The "Future Lilac Queens" float passes the DuPage Theater, which displays the 1936 film *The Trail of the Lonesome Pine* on its marquee. The float was ironic because no one knew that this would be the last parade for 20 years, a lonesome duration caused by the Depression and World War II. Sponsored by the Westmore Improvement Club, the "Future Lilac Queens" float won first prize among civic groups, but none of the girls ever got a chance to be queen.

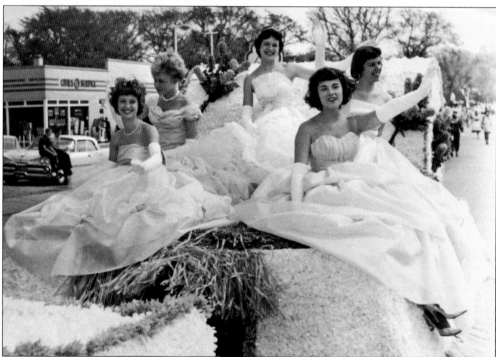

The Lilac Court float in 1961 carried Queen Betty Jean Barnet (center) and, from left to right, Lilac Princesses Joyce Gardner, Patricia Donath, Rebecca Fossdal, and Suzanne Long. Every Lilac Princess was required to have several formal gowns because there were many events during the festival in which they were to appear.

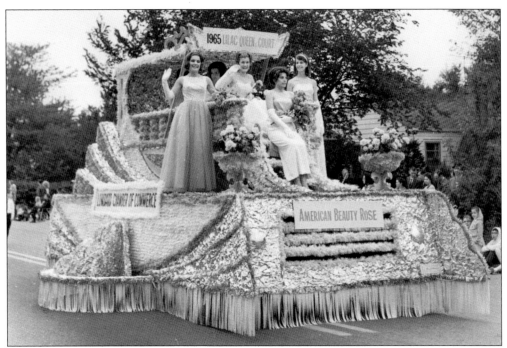

The Lombard Area Chamber of Commerce and Industry float featured 1965 queen Linda Chambers and princesses Bette Lynn Bell, Sue Crosby, Nancy Moon, Eileen Sajovic, and Helene Wlochall. Not all of the princesses are visible in this picture. There was no hard-and-fast rule about whether the princesses stood or sat during the ride. The queen often sat on a throne of some sort.

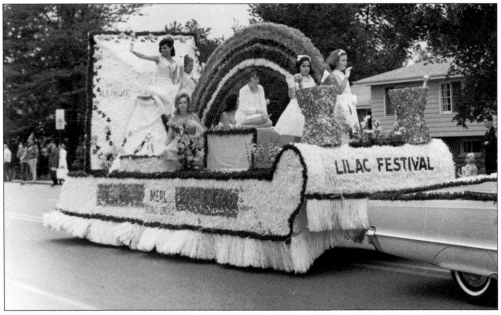

Miss Illinois joined the parade in 1967, sponsored by Merl Rexall Drug Store. This was also the year that another important addition was made to the parade, though not usually photographed: the village's new street-sweeping machine, which followed the equestrian entries. It was met with cheers and applause every year.

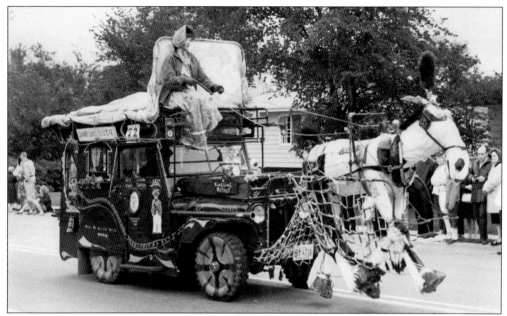

Novelty entries like "Dandelion Delight," shown here in 1967, made the parades fun for adults as well as children. Notice that the "horse" seems to have toilet plungers for legs and feet! Clowns often walked beside or between floats, playing with the crowds. In the early years, candy or toys might be thrown from the floats, but this was later deemed to be a safety hazard and forbidden.

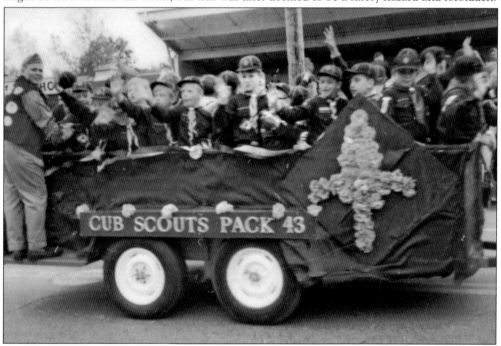

Cub Scout Pack No. 43 crowds a wagon in the 1968 parade. For safety's sake, children under the age of 16 were not allowed to walk in the parade but could ride in floats or wagons. In later years, preschools entered the parade with parents pulling their children in toy wagons festooned with balloons and streamers.

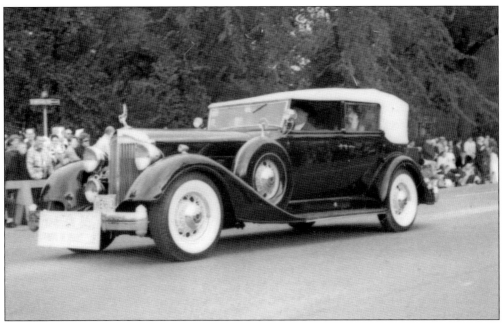

Antique cars, as shown here in 1968, were always a hit, especially when the owners and drivers dressed the part. These were members of the Antique Auto Association. Antique cars ranged from old Ford Model Ts, to flivvers, to bulgy cars from the 1940s, and eventually the sleek finned beauties of the 1950s. Antique automobiles have to be at least 25 years old, so as the years pass, the "antique" cars begin to look more familiar. In 1972, an ancient fire truck joined the parade, manned by "the Temperance Five," members of the Lombard Jaycees, complete with costumes, including lilac-colored hats and ties.

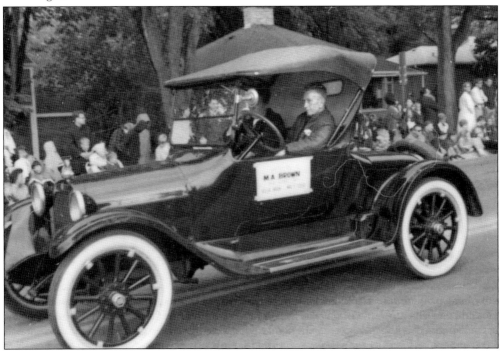

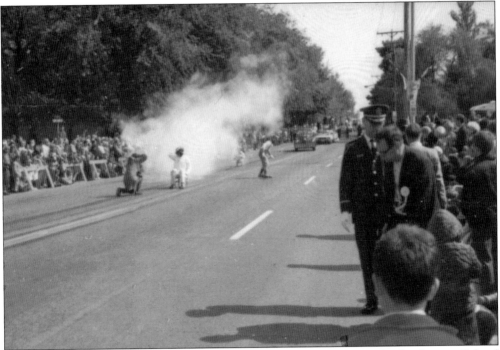

Clouds of smoke engulf the crowd during the 1968 parade. This may be the Service School Command Drill Team from the Great Lakes Naval Training Center. The parade often stopped so that a group could perform at various points along the parade route, as well as in front of the reviewing stand. These stops and starts resulted in gaps and bunching during the parade.

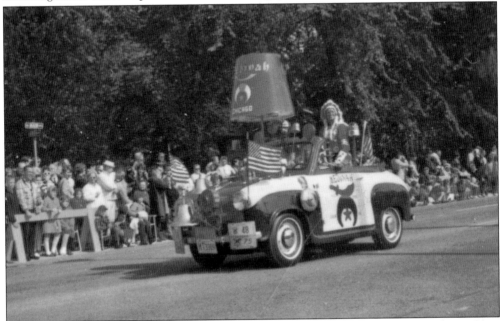

The Shriners participated in the Lilac Parade, as shown here in 1968. Their car has their emblem on the side and sports the Shriner fez. When they drove their little "flying carpet" cars in the parade, spectators had to keep their toes out of the street or risk getting them run over.

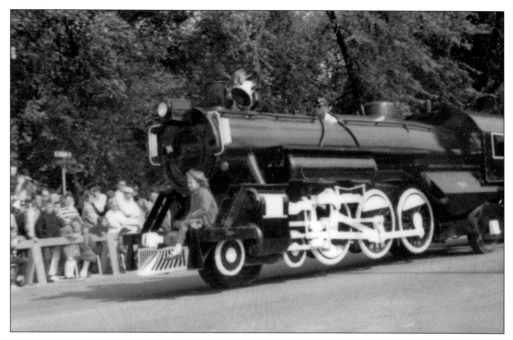

The railroad came through Babcock's Grove (eventually renamed Lombard) in 1849 and was vital to the growth of many Chicago suburbs. Lombard actually had three railroads cutting across town, so it was not unusual to see railroad equipment portrayed in the parade, like this old steam engine in 1968. This old-timer was followed by a float of a futuristic aerotrain diesel locomotive. Both entries were from the Electro-Motive Diesel American Legion Post from McCook, Illinois. McCook was the location of the massive plant where Electro-Motive engines were assembled.

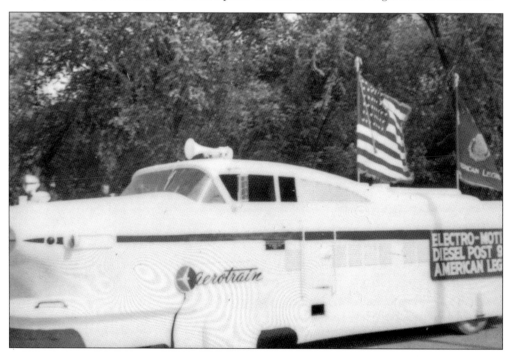

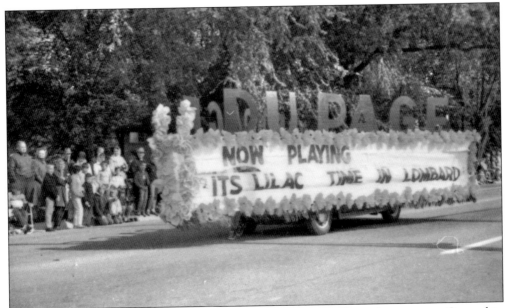

The DuPage Theater float showed "It's Lilac Time in Lombard" on the marquee. Opened in 1928, the DuPage was a splendid Fischer-Paramount Theater, with Spanish gardens decorating the interior and starry skies on the ceiling. The characteristic exterior, with its large marquee hanging over the sidewalk, was visible to commuters from the railroad tracks.

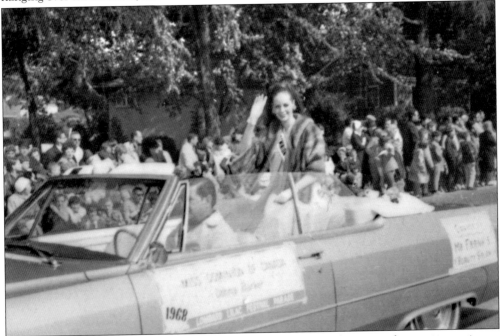

Besides floats and marching bands, there were the open cars with various dignitaries waving to the crowds. The parade marshal, Lombard's man of the year, and Lombard's woman of the year rode in convertibles. Sometimes politicians rode, but more often state senators and representatives walked the parade route. Parade rules forbid electioneering during the parade, but waving and shaking hands is acceptable.

The Glenbard East High School Marching Band members show off their uniforms in 1969, in spite of the rain. The parade went on, rain or shine. One year, because of the extreme heat, the high school band wore matching tee shirts and jeans instead of their wool uniforms. Baton twirlers unfortunately endure the agony of colder weather.

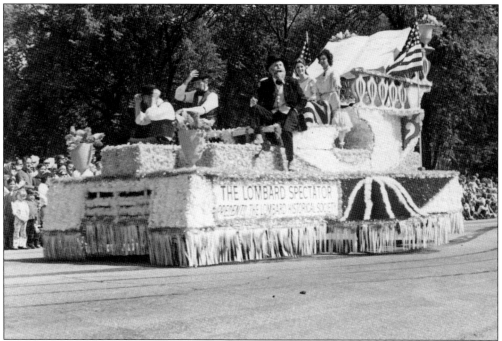

In the 1972 parade, three floats were made by Lombard businesses honoring Lombard organizations. Brust Funeral Home honored the Lombard League of Women Voters, and Merl Drug Store honored the Lombard Park Players. The *Lombard Spectator* float, shown above, was presented by the Lombard Historical Society. Formed in 1970, the society opened the historical museum at 23 West Maple Street in 1972, even though it was still undergoing restoration.

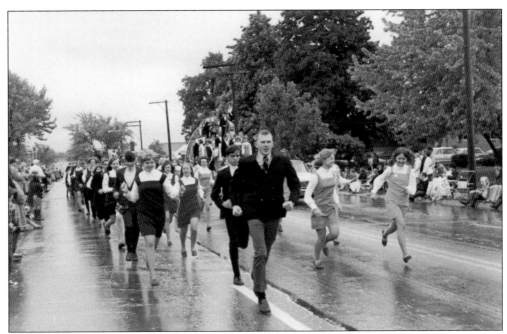

In spite of the cold, rainy weather, Sing-Out Lombard, a group with about 95 members, showed their enthusiasm in 1969. They may have been rushing to take their positions to perform in front of the reviewing stand or just to catch up to the rest of the parade after their performance. Sing-Out Lombard was comprised of youngsters age 14 through 18 years old. Shown below walking alongside the float is James Edwards, director of the group. Later rules of the parade dictated, "all units must maintain a FORWARD MOTION." This helped eliminate many of the backups that occurred as different groups stopped in front of the reviewing stand.

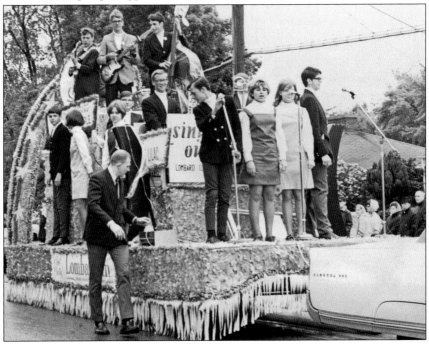

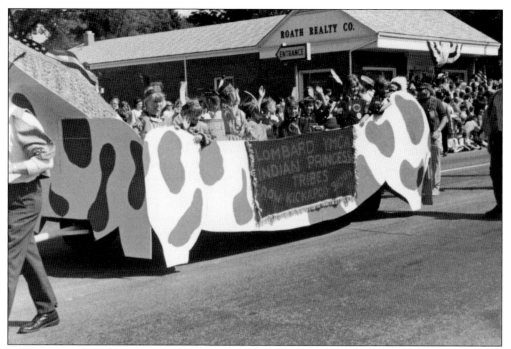

The YMCA father-and-daughter club Indian Princesses often participated in the Lilac Parade. For the safety of the children, they are on a decorated float pulled by a car. Regardless of the theme of the parade, they dressed in their traditional Indian garb, dresses for the girls and war bonnets for their fathers.

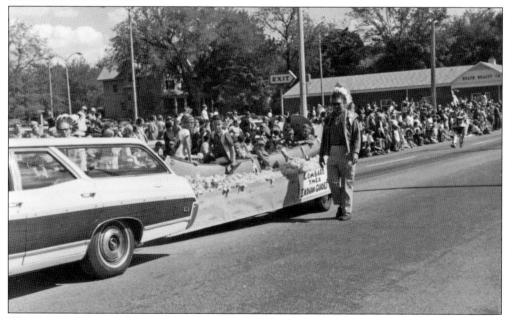

The YMCA father-and-son Indian Guides were in the 1969 parade. The children rode the float, and the fathers ran alongside, making stops along the way to color "Indian war paint" markings on the faces of the curbside children. Many of the kids tried to get as many colors on their faces as possible to outdo the others, while some tried to avoid being marked at all.

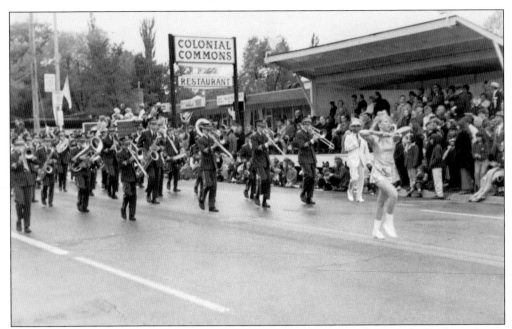

The Lombard Junior High School Band "A" marched in the 1969 Lilac Parade. Tradition has it that the high school and junior high school bands took turns leading the parade. In 1969, the junior high may have been at the front of the parade after the fire engines. In spite of possible damage to valuable instruments by the rain, the parade went on.

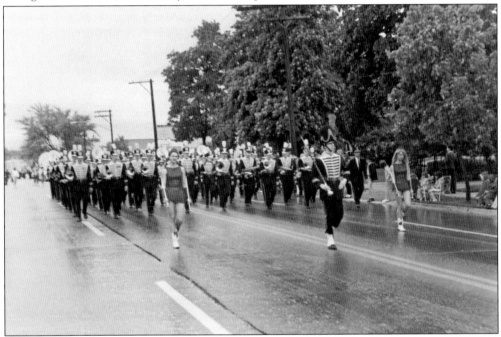

The Glenbard East High School Marching Band brought up the rear of the parade in 1969, following the queen and princesses float. The crowd behind this last unit swarms into the street to get to their cars before the traffic builds up. Though nonrestrictive in the early parades, in later years, crowd control was strict about not being in or crossing the street during the parade.

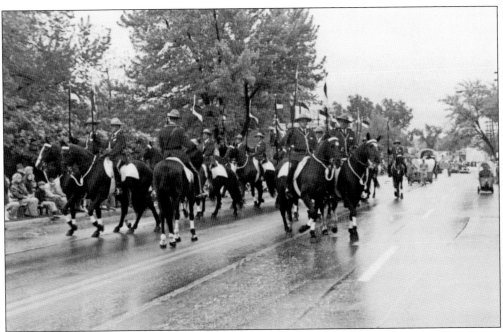

A unit of mounted police was provided by a men's fraternal society in the 1969 parade. They drilled at regular intervals to show their equestrian skills, not just at the judges' reviewing stand. This provided extra entertainment while maintaining a forward motion, as required by parade rules.

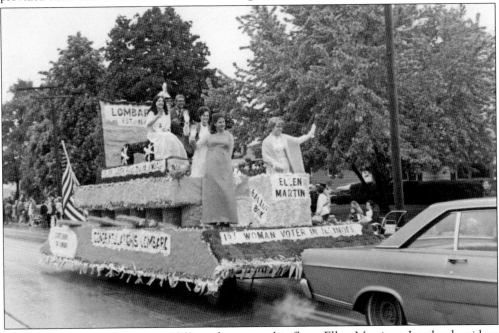

Lombard's centennial year was 1969, as shown on this float. Ellen Martin, a Lombard resident and Chicago attorney, demanded the right to vote in a local election, which flabbergasted the three male polling judges in 1891. Martin pointed out a loophole in the town charter that did not specify that only men could vote, and she and her friends voted some 29 years before the 19th Amendment gave the right to vote to women across the country.

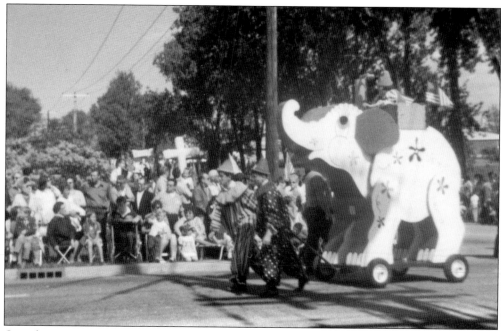

One clever parent converted a child's wagon into a great pink elephant that had room for some kids in the pagoda on its back. Parade watchers in 1970 were impressed as the great elephant, pulled by two clowns, moved down the street to cheers for its ingenuity.

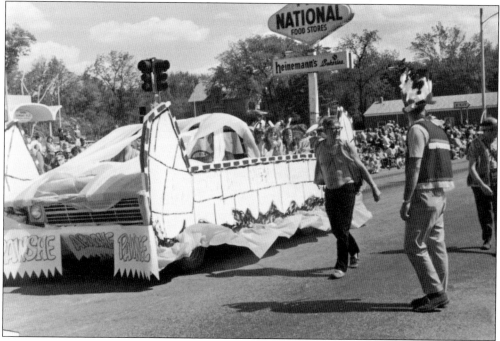

Even some personal pickup trucks were modified into floats. In this example, the truck is now an Indian canoe with the Indian Princesses on board surrounded by their fathers, who painted faces and passed out candy. The National Food Stores sign dates this photograph to the 1970 period. Later this store was transformed into the Mr. Z Grocery on Main Street.

A Moorish equestrian unit heads west along St. Charles Road and passes the village's second Jewel Food Store east of Elizabeth Street in the extended version of the parade route used in 1970. The first Jewel Tea, a small store by today's standards, had been just west of Park Avenue on St. Charles Road, and the third, a supermarket, was built at Lombard Pines Plaza at Main Street and Roosevelt Road.

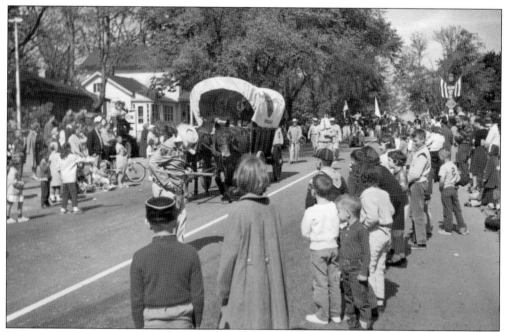

This covered wagon seems to draw the crowd out into the street. Parade officials and police patrol the sidelines, trying to keep the crowd above the curbs. Sometimes as early as two days before the parade, the street parkways would be lined with lawn chairs and blankets, each marking out parade-watching territory.

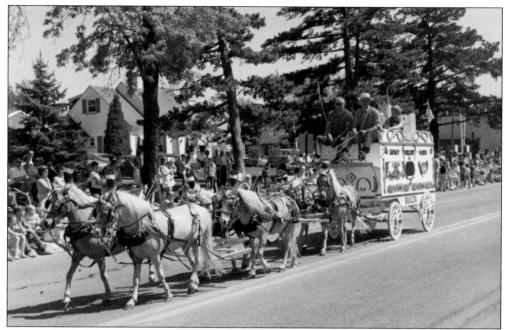

Charles Builta's authentic circus wagon was featured in the May 16, 1971, parade. The wagon was pulled by six matching ponies as it rolled down Main Street, passing Washington Boulevard. Undersized compared to standard circus wagons, this wagon was constructed for parade use through a town or within the circus tent.

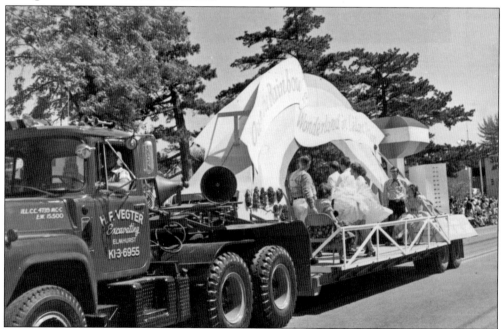

Another unit in 1971 was the float pulled by a heavy-duty six-wheel tractor owned by the H. F. Vegter Excavating Company of Elmhurst. The members of the Square Dancing Club of Lombard showed their skills as music boomed from the audio system and the dancers carefully followed the instructions while watching their feet.

The crowd lined Main Street several people deep to see the annual Lilac Parade, sometimes in jackets, like here in 1968, and sometimes in shorts, sun block, and shades, depending on the weather. There was also a reviewing stand set up along the parade's route to give the parade judges and special guests a better view.

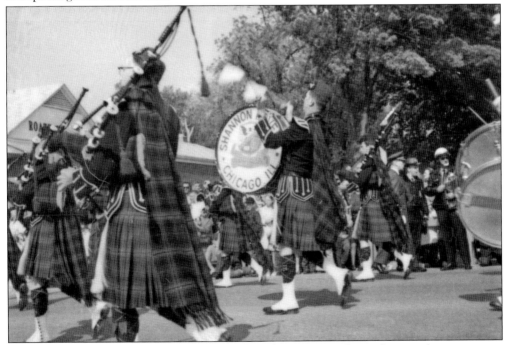

Bagpipes, whose wailing notes are audible for long distances, are the perfect parade instruments. Pipe and drum bands were always favorites in the Lilac Parade, like this one in 1968. Most parades had several groups of pipes and drums, each one strutting proudly in their own plaids, with tassels swinging merrily at the top of their knee socks.

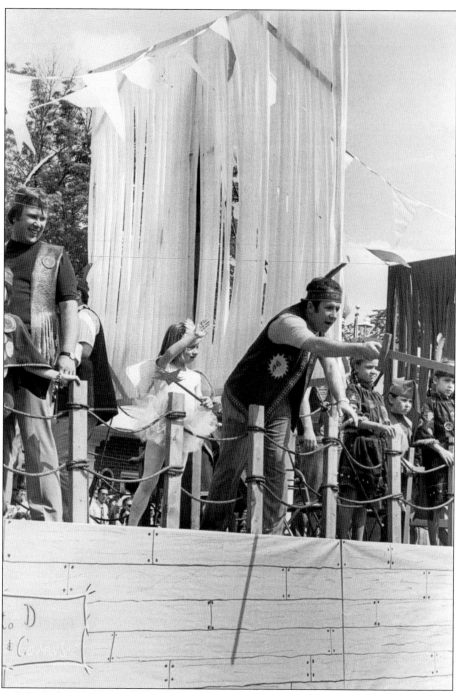

One of the Indian Princess fathers gestures with his wooden sword as they pass along Main Street during the 1973 Lilac Parade. Some of the older children look a little glum, but a fairy at the center was glad to see the crowds along the way. While candy tossing had been the norm for years, a village ordinance forbade the throwing of candy, gum, novelty items, water balloons, or election material, as it was considered a safety hazard. Children who darted into the street to pick up stray candy often ignored the following floats and seemed at risk.

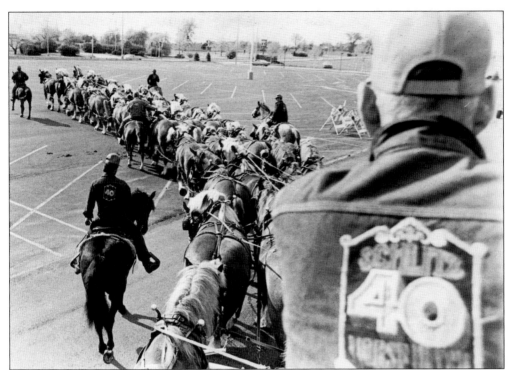

The above picture looks over the shoulder of the driver of the Schlitz 40-Horse Hitch in 1975, waiting for his turn in the parade. This was the world's largest team of horses. It took a big area to get them ready to go; this is possibly the high school parking lot. In the photograph at right, the Schlitz 40-Horse Hitch stretches down the street in the 1975 Lilac Parade. This was a 40-ton unit, measuring 135 feet long, with Belgian draft horses four abreast in 10 rows pulling an ornate circus wagon, complete with its own band. Visible behind the accompanying riders is the ever-popular street sweeper.

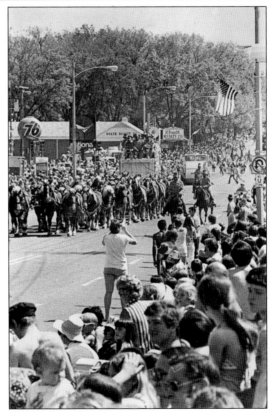

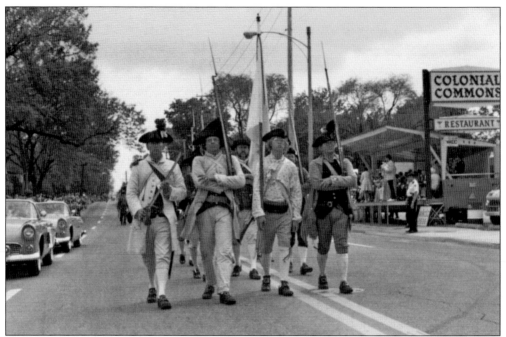

A Revolutionary War color guard leads a section of the 1976 Lilac Parade as it passes Colonial Commons on Main Street in a curious coincidence. Note the two convertibles on the left, waiting for a moment to sneak by and rejoin their unit somewhere ahead.

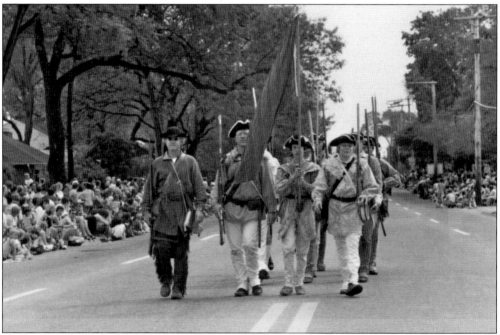

A variation on the Revolutionary War color guard, this unit was seen farther up Main Street at Washington Street in the 1976 Lilac Parade. The bicentennial theme was apropos for the springtime event. Washington Boulevard, on the right, split and bordered the Lombard Cemetery at this block. People crowded between the cemetery fence and the street to view the parade.

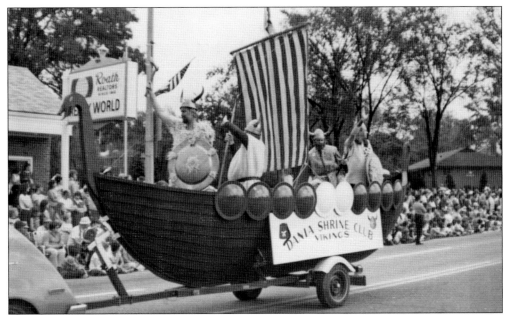

Passing Colonial Commons, this Shrine Club float of Vikings strikes fear into those who gaze from the sidelines. With the dragon head at the bow, the Viking men brandish their arms as they plan to pillage the neighborhood. Vikings predate the Revolutionary War period by several hundred years.

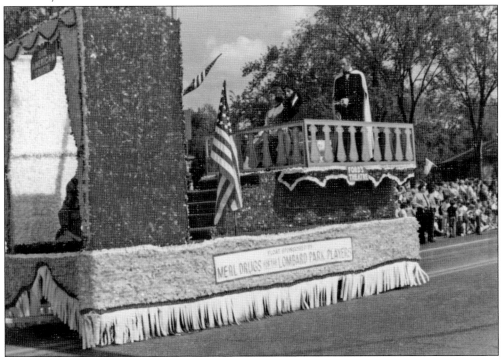

Merl Drugs and the Lombard Park Players float showed the interior of Ford's Theater in Washington, D.C., with Pres. Abraham Lincoln sitting in the box watching the play *Our American Cousin*, while John Wilkes Booth stands behind him menacingly, threatening to pounce with his derringer.

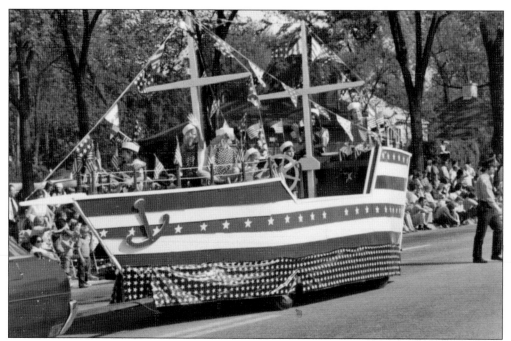

Children man this New England Colonial ship sailing from Europe to the American shores. Resplendent in red, white, and blue stars and stripes, an unlikely scheme for a Puritan vessel, the float seems to represent the hordes of immigrants that flocked to America's shores in the 1700s.

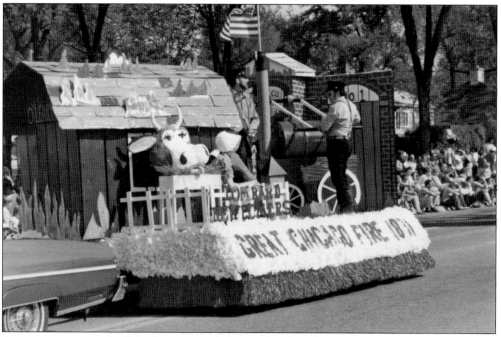

An interesting stretch of the bicentennial theme, this float depicts a crazed cow, Mrs. O'Leary, and her burning barn near the river's edge in Chicago, and two firemen from Company No. 1 trying to extinguish the flames. "Great Chicago Fire, 1871" sets a scene but somehow misses the point of the 1976 Lilac Parade.

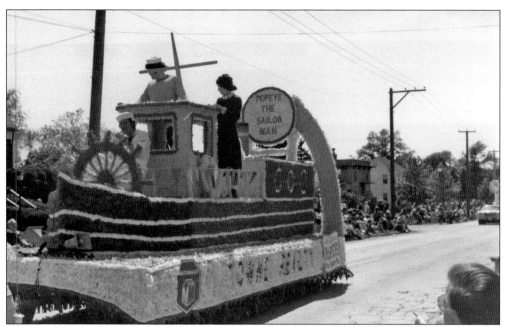

With cartoon characters as the theme, this float features Popeye the Sailor riding on the Marquardt Realty entry. Could that be Bluto and Olive Oyl standing on the deck of the ship as it sails by in the 1978 Lilac Parade?

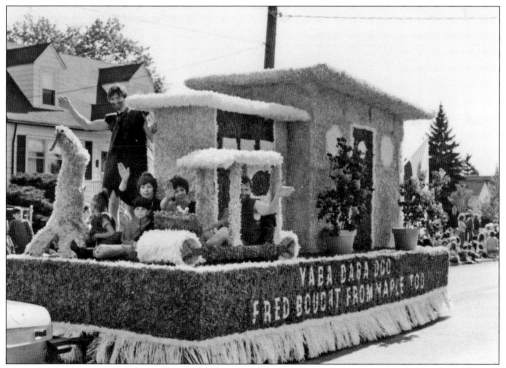

The Maple Realty Company float featured Fred Flintstone shouting "Yabba dabba doo!" and the Fred-mobile. The caption read, "Fred bought from Maple too." Is that a dinosaur on the left-front corner?

Lombard's Lilac Queens (and Princesses)

1930 - Adeline Fleege
1931 - Alice LaFetra
1932 - Rebecca Howe
1933 - Mildred Fryer
1934 - Ruth Melka
1935 - Sylvia Asher
1936 - Jean Curtis
1947 - Betty Bean (Omond Childs, Helen Murphy, Charlotte Reis, Lora Standish)
1948 - Marilyn Shearer (Pat Dearinger, Rosemary Kett, Jeanne Krause, Patty Moloney)
1949 - Patricia Fuller (Pat Byrne, Jane Louise Freund, Norma Jean Wendt, Donna Whiteley)
1950 - Joanne Hale (Ruth Auberg, Donna Jean Durham, Nancy Hoag, Patricia Murphy)
1951 - Patricia Sheridan (Shirley Dammann, Margie Johnson, Lynn Koykar, Barbara Spence)
1952 - Joan Archbold (Carolyn Kolze, Marlene Lindsay, Nancy Meyers, Geraldine Miller)
1953 - Joye Wardecker (Inga Horst, Lois Lane, Raenata Lehman, Patricia Wolff)
1954 - Jackie Ramey (Connie Bednarz, Naomi Jorgensen, Eileen Nicholson, Judith Tomamichel)
1955 - Carol Brown (Lois Albertson, Sandra Larson, Arliss Paulson, Nancy Widman)
1956 - Laura Kaiser (Jean Bauman, Judi Moore, Arlene Piepers, Pat Weber)
1957 - Karen Ridgway (Jane Ferguson, Judy Maisel, Shirley Matlock, Betty Wingard)
1958 - Deanna Domler (Phyliss Francis, Gail Hazekamp, Barbara Snider, Barbara Staedke)
1959 - Beverly Carlson (Jody Cremerius, Carol Hesselgrave, Mary Novak, Kathy Stanton)
1960 - Michele Little (Julie Ferry, Delores Heide, Beverly Kushman, Judy Smith)
1961 - Betty Jean Barnet (Patricia Donath, Rebecca Fossdal, Joyce Gardner, Susanne Long)

1962 - Connie Capitanelli (Sharon Boyer, Lou Chambers, Judith Ann Fleege, Carol Jordan)
1963 - Lavonne Tanswell (Sherrill Beckwith, Nancy Carlson, Karen Kluender, Sandy Schroeder)
1964 - Carol Lynn Burke (Janice Hildenbrand, Susan Ness, Susan Larson, Margaret Thompson)
1965 - Linda Chambers (Betty Bell, Sue Crosby, Nancy Moon, Eileen Sajovic, Helene Wlochall)
1966 - Bonnie Boal (Jeanne Eme, Glenda Klein, Lyn Noonan, Joanne Wille)
1967 - Colleen Burke (Karen Anderson, Suzanne Beavers, Gerie Holsinger, Linda Larson)
1968 - Sandie Wlochall (Mary Bicicchi, Gayle Cunningham, Judy Larm, Sandy Thompson)
1969 - Susan High (Susan Gerhardt, Betty McMillan, Eileen Smietana, Carolle Tanser)
1970 - Bonnie Shultz (Rhonda Davis, Carol DeWitt, Joan Kennedy, Barbara Schatz)
1971 - Jean Marie Amundsen (Elaine Bellock, Patricia DeWitt, Laurie Kucera, Anita Nowak)
1972 - Doranne Moulder (Jayne Lee Buettner, Peggy Kusak, Ruth Maas, Sherry Steiger)
1973 - Barbara Wetzel (Gail Ann Ferrier, Tina Geroulis, Carol Haefner, Judy Reuhl)
1974 - Donna Lee DeForest (Penny Chippas, Donna Johnson, Carrie Kravchuk, Suzanne Piche)
1975 - Debbie Baumann (Lynn Cantua, Janet Grass, Betty Rider, Janice Swanson)
1976 - Jenneine Rowley (Ann Cadagin, Laurel Kleefisch, Teresa Owens, Loretta Rakebrand)
1977 - Elizabeth Pool (Melody Chrisman, Carrie Dexter, Lou Ann Santelli, Cindy Scavone)
1978 - Kathy Happel (Nora Ferris, Sharon Hattendorf, Mary Rowley, Pauline Ureta)
1979 - Gaye Rivers (Susan Bethke, Paula Blackwell, Linda Moorhead, Heidi Nordstrom)
1980 - Kathi Lynch (Laura Doyle, Karen Erland, Selina Moriarty, Kitty Thomas)

This is a listing of all the Lilac Queens and Lilac Princesses from 1930 through 1980.

ABOUT THE SOCIETY

The Lombard Historical Society was incorporated in 1970 in response to Lombard's centennial celebration of 1969. It has since provided hundreds of thousands of visitors with a look at Lombard's past and an understanding of its place in history through its two historic house museums, established in 1972 and 1999. The society participated in the 2008–2009 Lombard Cemetery restoration in conjunction with several other community organizations and the Village of Lombard.

The Lombard Historical Society exists to enrich Lombard's sense of tradition and heritage, and to foster a commitment of preservation in the community. The society's mission is the collection, interpretation, preservation, and presentation of information and objects concerning the history of Lombard, Illinois. The purpose of the Lombard Historical Society is to investigate and study the history of Lombard and the vicinity; to acquire, mark, and conserve historical sites; to collect, preserve, and display papers, books, records, relics, and other items of historical interest; to identify and protect historical buildings; and to cooperate with the Lombard Historical Commission in its acquisition, maintenance, and operation of historical sites and buildings, specifically the Victorian Cottage at 23 West Maple Street and the Sheldon Peck Homestead at 355 East Parkside Avenue.

www.arcadiapublishing.com

Discover books about the town where you grew up, the cities where your friends and families live, the town where your parents met, or even that retirement spot you've been dreaming about. Our Web site provides history lovers with exclusive deals, advanced notification about new titles, e-mail alerts of author events, and much more.

MADE IN THE USA

Arcadia Publishing, the leading local history publisher in the United States, is committed to making history accessible and meaningful through publishing books that celebrate and preserve the heritage of America's people and places. Consistent with our mission to preserve history on a local level, this book was printed in South Carolina on American-made paper and manufactured entirely in the United States.

This book carries the accredited Forest Stewardship Council (FSC) label and is printed on 100 percent FSC-certified paper. Products carrying the FSC label are independently certified to assure consumers that they come from forests that are managed to meet the social, economic, and ecological needs of present and future generations.

FSC
Mixed Sources
Product group from well-managed forests and other controlled sources

Cert no. SW-COC-001530
www.fsc.org
© 1996 Forest Stewardship Council

Find Your Place in History.